Wicked Women
of New Mexico

DONNA BLAKE BIRCHELL

THE
History
PRESS

D0905716

Published by The History Press
Charleston, SC 29403
www.historypress.net

First published 2014

Manufactured in the United States

ISBN 978.1.62619.128.0

Library of Congress Cataloging-in-Publication Data

Birchell, Donna Blake.
Wicked women of New Mexico / Donna Blake Birchell.
pages cm
Includes bibliographical references.
ISBN 978-1-62619-128-0
1. Women--New Mexico--Biography. 2. Murderers--New Mexico--Biography. 3.
Prostitutes--New Mexico--Biography. 4. Women gamblers--New Mexico--Biography. I.
Title.
F800.B57 2014
364.1092'5209789--dc23
2014001904

This book is dedicated to all the women of the West, who had to be tough as nails to survive in an unforgiving land and were strong enough to forge a wide, new path for those who would follow them into the future.

Well-behaved women seldom make history.

—Laurel Thatcher Ulrich

Contents

Acknowledgements

As always, much gratitude and thanks go to Samantha Villa, who helped me launch this amazing journey into authorship. I can't thank you enough, my friend!

A special thank-you to Mo Palmer of Albuquerque, who has kept history alive with her amazing newspaper articles and compiled the invaluable research on Lizzie McGrath.

Words cannot express how much the work of Brea Black of the Topeka Public Library meant to the success of this project. Many thanks!

Jim, curator of the Black Range Museum—your personal tour and insight was priceless. Thank you for the fascinating glimpse into the life of Sadie Orchard.

Thank you to Glen Frye, photo archivist at the Albuquerque Museum, for going the extra mile.

To the staff, volunteers and docents of the Living Desert Zoo and Gardens State Park who cheered me on through the dreaded deadline phase—sorry for the drama!

I would be nowhere without friends like James Owens and Patricia Kiddney, who work every day to keep history alive. Thank you is not enough, my friends!

To my editors, Jerry Roberts and Will Collicott, I truly appreciate your enthusiasm and guidance during this project. You made my experience with this book an enjoyable one. Many thanks to all the staff at The History Press for your dedication in keeping history alive.

Acknowledgements

Without my family's support, this book would not be possible. So, with deep gratitude and heartfelt love, thank you very much Jerry, Michael and Justin Birchell for your encouragement. You mean the whole world to me! Jerry, thank you for navigating Highway 152 between Hillsboro and Silver City, which proved to be an extremely gut-wrenching ride!

Introduction

SURVIVAL

The environment of the West was one of pure survival. A six-gun or a rifle was likely the only protection (and/or justice) a person had in this wild land. The sheer expanses of land led to the necessity of creating one's own justice system and survival skills. Men seeking gold, asylum or a new life forged ahead through the unknown to be met, on many occasions, with death. Only the tough could survive, and this was certainly thought to be no place for a woman.

In this book, you will meet some of the strongest women ever to have lived in the West. All came from circumstances that led them to seek out the possibilities the Land of Enchantment held for them. Since New Mexico did not become a state until 1912, territorial justice was sometimes slow to respond or, in some cases, as you will see, completely heartless. This was certainly a man's world, and women, although welcome due to the rarity of their sex in the West, were treated as little more than property to be traded or to be dealt with accordingly.

It is not my intention to judge these women in any sense of the word but to give a rare insight into the lives of the subjects so that the reader will be able to experience a way of life in which survival was often minimal at best. Also, this is not to glorify the lifestyles and choices made by the subjects of the book but to illustrate the strength of the human spirit and what people will do to survive. The fine line we walk in trying to find the true essence of

these ladies is the same one that they stepped over continually, many without conscience or shame.

It is also hard not to wonder at the mental condition of the most violent women featured, what drove them to commit such horrendous acts of violence and what the prosecutors of today would do with their cases. In many situations, a coy smile and a bat of a flirty lash was enough to convince a jury of their innocence. Times were definitely different then.

BACKSTORIES

Everyone has a story to tell. The backstories of the women in this book are generally tragic. Each had a traumatic event that either triggered the responses given or further exasperated their already fragile psyches. The fact that they were able to go forth under the circumstances they were dealt, in several cases, was nothing less than a miracle.

Wickedness is not a new concept, and the choices made by these ladies—whether by free will or forced—had strong influences on the formation of towns, governments and even laws in the Old West. Women, as the objects of a man's sex drive, were powerful in a harsh region of the country. New Mexico is not for the weak; you must have a backbone, conviction and stubbornness to survive the elements, something true even today. Although a majority of the women were not originally from New Mexico, they flourished amongst the cacti, mesquite bushes, piñon trees and rattlesnakes to make this beautiful land their home.

Some were convicted or suspected murderers, as was the case with Paula Angel, Dora Dwenger, Valentina Madrid, Alma Lyons and Ada Hulmes. Others, such as Sadie Orchard, Lizzie McGrath, Mildred Cusey and Beulah M'Rose, led the life of shady ladies. Still others, like Lottie Deno and Doña Tules, took to the gambling way of life. And then there was Bronco Sue, who was a unique combination of all of the above, with cattle rustling thrown into the mix, and Belle Siddons, who was not only an expert monte dealer but also a convicted Confederate spy.

No matter the way of life, there was at least one redeeming quality—albeit hard to recognize in some cases—in most of these ladies.

FORGING ON

Each of the women featured in this book added to the spice and flavor of the New Mexico Territory. Some may think they contributed nothing but mayhem, without any redeemable qualities, but in truth, they added realization about the enormous amount of strength needed to be a woman in the West—while also creating, in some cases, a great amount of havoc and wickedness for their victims. The results of their actions gave the citizens of the towns in which they lived many hours of salacious testimony and gossip. For the most part, history has not been kind to the subjects of this book. Soiled doves, parlor girls, fallen angels, cattle rustlers, murderesses, gamblers and spies were but a few of their names as told in local newspapers and dime novels. Human nature draws interest toward the macabre and unusual, giving us a glimpse into a world totally different from our own. And some of us even secretly wish that we had half the strength and nerve of any one of these unusual women.

THE LAND OF ENCHANTMENT

The one thing that truly ties these ladies together, other than their deeds, is the fact they all were either born or ended up in New Mexico. Known for its remoteness and lawlessness, New Mexico is the perfect place to harbor people from all walks of life. The state's turquoise-blue skies, open vistas and blend of cultures make it one of the most unique places in the country. If you have never visited New Mexico, I highly recommend you do so. Retrace the footsteps of the women in this book to get a true feel for what they might have seen and experienced. Witness an awe-inspiring sunset behind the Organ Mountains; roam the wine country of the Mesilla and Rio Grande Valleys; drink in the history that surrounds the mountain mining towns of Silver City, Kingston and Hillsboro; be amazed at the beauty of the Carlsbad Caverns; and, finally, retrace the footsteps of Billy the Kid and Bronco Sue in the White Sands of the Tularosa Basin. Give in to the desire to visit the stark, breathtaking beauty that will surprise, welcome and surround you as you roam the country roads and interstates that connect every corner of this magnificent state.

The Land of Enchantment is truly a state of diversity, as symbolized by the Zia on its flag. Four stages of life, four seasons, four directions and four

times of the day are all included on the yellow-and-red New Mexican flag, a symbol unique to the state.

Read this book with the knowledge that these were much different times and mindsets than we have today. So sit back and get lost in the wicked stories of adventures in another life and era.

PART I:
LADY KILLERS

Paula Angel:
Hanged Twice for Love

C rimes of passion span the history of the world from biblical days to the present. A woman scorned can be dangerous and, in many cases, lethal. Such was the case with Paula Angel.

Also known as Pablita Martin, Polonia Angel or Pablita Sandoval to some, Paula Angel made a mistake that often ends badly regardless of which era a person lives: she fell in love with a married man, and he with her. The initial excitement, fear of discovery and thrill of having the complete attention of someone new was too much to ignore for the young couple. Their deep lust drew both of them into a world of deceit, lies and secrecy.

But as we know, sometimes one of the parties involved in such a relationship has a change of heart or cooling down period and tries to end the tryst. When Juan Miguel Martin, a married man with five children and a prominent businessman from a powerful family, realized the error of his ways and broke it off with Paula, the celebrated beauty of the Las Vegas, New Mexico area calmly accepted the news while giving the appearance of going about her life without much distress.

We are not certain of Paula's exact age at the time; the accepted range is anywhere between nineteen and twenty-six. (While there are no verifiable written records, she is thought to have been born in 1834.) Either way, she was a young woman in her prime who had given everything to a man who had spurned her to return to his wife. Although a great scandal would have occurred if Juan Miguel had stayed with Paula, this did not concern her. She had been pushed aside by the man she loved, which, in her mind, was a crime.

If Paula had come from the "other side of the tracks" or, in this case, the other side of the Gallinas River, one might have expected the wrath she was to encounter. But she was from a highly respected family who happened to live near Loma Parda, a small farming community located along the Sapello River, about twelve miles north of Las Vegas, and had seen many suitors vying for their daughter's attention, all of whom were refused.

Some stories indicate that Paula was married with children, a prostitute and/or a witch, but no records survive to substantiate these claims.

The daughter of a man who was skilled in both woodworking and adobe-making and a mother who taught her the trade of being a seamstress for the soldiers' wives at nearby Fort Union, Paula worked hard for a living. Although many soldiers vied for her attention, she unfortunately lost her heart to a married man.

Exactly who initiated this affair is a mystery, but the issuance of promises no doubt was involved, and they were now broken. It was evident through his past actions that Mr. Martin did not take vows or promises to heart.

Several weeks after the painful breakup, Paula sent a message to her former lover requesting to see him "one last time." Martin, not sensing anything sinister afoot, agreed to meet her in an alley so that they would not be detected by any nosey passersby.

Paula, of Spanish Conquistador heritage, was a proud beauty, and she took special care in preparing herself for their reunion. Her best dress was complemented by a dainty shawl to protect her from the cool spring evening. It was certain that Paula wanted Juan Miguel to see what he had given up and subsequently regret his foolhardy decision.

One can imagine the meeting between the two, who were unknowingly at such opposite ends of the spectrum about what to expect from the other. Paula, in her youth, surely envisioned Juan Miguel groveling at her feet and begging forgiveness. Juan Miguel, who most likely still loved Paula but was now recommitted to his large family, may have seen the meeting as a way to appease the young woman so that she would not remain angry with him.

It is not written what were the exact words exchanged between the couple, but the results spoke volumes. Be it for protection or premeditation, Paula produced a kitchen knife, which she had hidden in her wrap, when the scenario did not go to her advantage and stabbed her former lover in the back, just below the left shoulder, during the final embrace she had demanded.

Juan Miguel, stabbed in the alley behind the brothels and gambling rooms he had been frequenting, took his last breaths in the Cantina Gallina.

Immediately arrested for the crime, Paula was taken into custody and secured in a local family's home. Her arraignment was held on March 23, 1861.

Paula's subsequent trial was to be the most attended event in the region. Scandalous court testimony generally rendered courtrooms with standing room only, and this was no exception.

Even in trials involving murder, an all-male jury usually found it difficult to impose a harsh sentence on a woman—mainly due to the scarcity of her sex in the West. In Paula's case, however, it appeared the opposite happened. Convicted of her crime, Paula was quickly sentenced to be hanged without mercy. Many have questioned the reasons behind this obvious callousness toward the defendant. Maybe the fact that the victim came from a wealthy, influential family sealed Paula's fate more harshly.

Paula was defended by famed attorney Spruce M. Baird, nicknamed "Colorado" due to his red beard. Baird, a Confederate sympathizer who himself would be brought up on treason charges in 1862, spoke to the jury both in English and Spanish as he passionately pleaded his client's case. Paula's plea of innocence fell on deaf ears despite the fact that the foreman of the jury was also from Loma Parda and testified to her good character. The men of the town and court set out to make an example of the perpetrator of this cold-blooded killing of one of their prominent sons.

Juan Miguel's family sought the support of Colonel J.D. Sena of the New Mexico Volunteers, who was stationed in Santa Fe at the time. Sena had been seen walking around Las Vegas with a smirk on his face and gifting money to gain favors in the community. It was a not so closely kept secret that the Martin family would accept nothing less than the conviction and subsequent death of Paula Angel.

Judge Kirby Benedict, who was said to be one of the more lively characters in New Mexico's history as a Civil War participant who would later become the chief justice to the state supreme court, passed the unthinkable sentence of death by hanging on the young Paula Angel after she was found guilty. The officers' wives for whom Paula had sewn dresses were shocked by the severity of the sentence. While they didn't condone the crime, they thought an easier fate should have been imposed.

Territorial judges were appointed by the U.S. president, and Benedict had been appointed by both Lincoln and Buchanan. Benedict was required to hold court in New Mexico's original nine counties twice a year but was also known to be a carouser.

When Benedict came to Las Vegas with his entourage of lawyers, they were often seen playing poker and drinking in the Buffalo Hall of the Exchange

Hotel. Upon witnessing the group, citizens sounded the alarm and reported them to the grand jury. The names of the attorneys were read in court the following morning, and each lawyer pleaded guilty and paid his fines. When Benedict's name was read, it is said that the judge stood up and yelled out his statement: "Kirby Benedict enters a plea of guilty. The court assesses his fine at $10.00 and costs, and what is more, Kirby Benedict will pay it!"

After his brush with the local law, Judge Benedict focused on his task at hand: sentencing a young woman to die. As the case was handed to the jury, Benedict wrote out instructions that would summarily lead to Paula's doom: "The defendant is guilty of first-degree murder, or not guilty of any crime."

With instructions such as these, the jury of her peers, against their best wishes, was not able to save Paula. Less than thirty minutes later, Paula was found guilty of homicide in the first degree. The judge declared, "Paula Angel is to be hanged by the neck until dead on Friday, April 26, 1861, between the hours of 10 o'clock in the forenoon and 4 o'clock in the afternoon."

Although Paula was allowed an appeal, Judge Benedict stated that it "should in no manner operate as a stay of execution." Today, an appeal would result in an automatic stay of execution, but in 1861, Benedict acted under the Kearny Code, which stated that stays of execution were discretionary with the court.

However, Paula's case was sent to the Territorial Supreme Court for appeal, citing jury tampering, court errors and new evidence. She had been tried under the code of laws given to New Mexico by General Stephen Watts Kearny, who had taken control of the Southwest in 1846. The military now controlled all of the courts in the territory.

Although Baird went to the commanding general, who informed him Paula's case would be given consideration in proper time, the appeal ended there. The court consisted of three district judges, including Benedict, who was the only one who voted in opposition to the stay.

Unfortunately for Paula, communications were slow since they arrived by horse and rider, and the stay appeal was not heard due to the vastness of the New Mexico Territory. It was well known that the Martin family's influence carried far more weight than a mere attorney.

The lack of evidence in Paula's case has led some to speculate whether her story was merely fabricated to sell newspapers and magazines. Her case did exist in the records of the San Miguel County Territorial District Court. However, when those records were transferred to the New Mexico State Records Center and Archives along with another group of records in 1976, it was discovered that Paula's folders were missing.

The timing of the case was unfortunate for Paula since the country was in the beginning throes of the Civil War, which garnered the attention of the majority of newspapers that would have ordinarily covered such a salacious case. Santa Fe authorities were not concerned with a mere woman in Las Vegas; they had larger events to worry about, such as the secession movement.

To add insult to injury, Paula was assessed not only the costs of her trial but also her hanging expenses. It is not known whether her family actually paid these charges once the execution commenced. The death warrant, signed by Governor Rencher, was lost for many years before finally turning up at the Huntington Library in California. It would later be returned to the New Mexico state archives.

Once remanded into custody, Paula was kept in a small room that doubled as a solitary confinement cell in the small sheriff's office. By orders of Judge Benedict, Paula was to be "secured by whatever chains and shackles necessary." When the family of the condemned brought food to the jail, they were allowed only three minutes of time with Paula, and this was through a small window situated high on an adobe wall.

Each day, as he walked by her cell, Sheriff Antonio Abad Herrera would take great pleasure in tormenting the condemned woman by reminding her of how many days she had left to live. The sheriff's reasons for anger toward Paula are unknown, but his disdain was extremely evident in his actions. It is possible that he was related to the victim or that Paula had once spurned his advances. Others think he was convinced Paula was a witch and that he was rattled by this.

By the time the fateful day came to pass nearly a month later, on April 26, 1861, Paula was a mere shadow of her former self—frail with a pale pallor. She had dropped so much weight that the people who saw her before the hanging were afraid she would not survive to be executed.

A gasp of horror could be heard from the huge crowd that had gathered right after sunrise as the young woman arrived at the cottonwood stand a few miles from the town plaza. To add insult to injury, Paula was forced to ride on her own coffin in a spring wagon on the short trip to the hanging spot, which was located northwest of Las Vegas near a country road along the Gallinas River.

The festive atmosphere, created by hundreds of spectators who traveled, in some cases, many miles from the Sapello and Mora River Valleys and as far away as Santa Fe and the Pecos Valley and who had brought their families and picnic lunches to the hanging, was to be dampened by the spectacle they were about to witness.

In his eagerness to rid the world of this wretched killer, or possibly in his own nervousness in front of the crowd, Sheriff Herrera hastened to complete his task. Paula stood on the back of the wagon, facing the throngs of people, while Herrera tied her feet together. After fitting the hangman's noose around her neck, the sheriff ran to the front of the wagon to spur on the team. No mercy was given Paula even in her manner of death—instead of a quick jerk, Herrera had plans for Paula to slowly swing and strangle.

Much to his horror, as well as to that of the crowd, when he looked back, Herrera saw a dangling Paula desperately struggling to release herself. In his haste to accomplish his duties, Herrera had forgotten to secure her hands.

As Herrera realized his mistake, he immediately jumped off the wagon and flung himself around one of Paula's legs, pulling down as hard as he could to expedite the execution. The crowd rushed in, having witnessed the sheriff's attempts to strangle his prisoner, to stop the atrocity as Paula kicked wildly at her executioner. When this did not work, a deputy joined in the efforts, grabbing her other leg.

One witness was not able to stomach the spectacle in front of him and, just in the nick of time, cut the rope from which all three people swung. Paula fell to the ground, her fragile frame unshielded from the impact. The noose was taken off from around her neck, and members of the crowd urged her to run. But this was impossible since, in her condition, she was unable to stand.

As Paula was again loaded into the wagon, the crowd became hostile. "You have already hanged her once. That satisfies the law!" yelled one witness.

Herrera protested, "The judge ordered her hanged until dead, and that is what I intend to do! Get out of the way and do not interfere with us!"

The men of the crowd then encircled the wagon, preventing it from being driven away. Pushed aside, Sheriff Herrera protested, "I have armed deputies among you. If you oppose due process of law, they will shoot!"

Colonel Sena, who was under orders to see to Paula's death, no matter what, stood beside Herrera in the wagon in support and spoke to the now furious crowd: "A prominent young man has been murdered on the very threshold of a useful life, and it has been the just decision of a jury and court that the murderess must die in expiation for her crime against justice."

Under the impression that the execution orders were in effect only until noon, a man in the crowd pointed out the time, to which Sena was quick to protest that the orders clearly stated Paula was to be hanged between the hours of ten o'clock in the morning and four o'clock in the afternoon. There was still plenty of time for Herrera to fulfill the orders.

The sheriff seized the opportunity Sena afforded him by trying to regain control of the situation. During this commotion, Sena was knocked off the wagon into an eagerly awaiting crowd, who pummeled him with punches and kicks.

The chaos gave Herrera and his deputy time to reposition Paula for a second hanging. Challenged by the crowd, Herrera would not fail this time. The wagon was violently jerked out from under the woman a second time with the use of a bullwhip, and this time her fate was secured.

Paula Angel was dead, strangled after a few painfully agonizing minutes. The horrified crowd grew silent as they realized the awful task had been

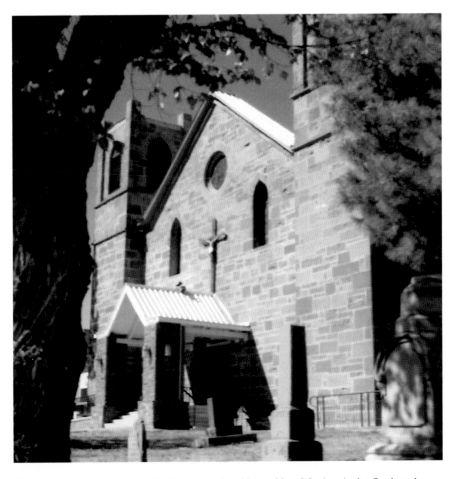

Our Lady of Sorrows Catholic Church in Las Vegas, New Mexico, is the final resting place of Paula Angel, although the exact location of her grave has been lost to history. *Author's collection.*

accomplished. Paula Angel was the first and last woman to be legally hanged in New Mexico and probably the first executed west of the Mississippi.

The men would not allow Herrera to retrieve Paula's limp body. They carefully wrapped the body in a blanket and, in a silent procession, carried her back to town on their shoulders. The exact location of her final resting place is lost to history, but it is written that she is buried in a special place in the corner of the cemetery of Our Lady of Sorrows Church in Las Vegas. Maybe it was there, in that forgotten grave, that Paula finally gained peace.

Sheriff Herrera wrote out and signed the death warrant in Spanish. When translated, it reads, "I, Antonio Abad Herrera, Sheriff of San Miguel County, New Mexico, do hereby make return on the within warrant, and do say that on the 26th day of April 1861, by the authority vested in me, I did hang Paula Angel, according to law of the territory and instructions of the court."

Herrera was shunned by the community after this despicable incident to the point where he became an alcoholic and died in disgrace. Local legend holds that the cottonwood tree from which Paula was hanged would present blood-red leaves in the fall instead of the traditional gold and that a cry could be heard as the wind blew through its limbs. The locals called it the "cottonwood that mourned." The tree has since been destroyed, but Paula's memory is kept alive by those who know her story.

Dora Dwenger:
Black Widow of the Territory

The brides of Henry F. Dwenger had a bad habit of dying, but when Dwenger met pretty Catharine "Dora" Hesser, it was his turn.

After the death of Henry's second wife, also named Catharine, on September 15, 1878, in Fort Smith, Arkansas, Henry turned his attentions to the young German girl who had served as his wife's nurse and also worked as a cook in his home. Dora had been employed as a domestic at a local hotel before joining the Dwenger household to care for the ailing second Mrs. Dwenger.

Henry's second wife died under Dora's care. Given the events that were to occur later, one must wonder about the circumstances of her death.

Dwenger needed help raising his sons, the eldest of whom, William, was described in the local newspapers as being "a weak-minded cruel sort of boy." The youngest, Josie, was only eight years old at the time of his mother's death. From Arkansas, the newly formed family would move west to the raucous mining town of Silver City, New Mexico.

After being married only three weeks to Henry, who was reported to be much older, Dora became very close with her eldest stepson and his friend William "Parson" Young, as they were much closer to her age. Neighbors whispered rumors about the young people even though they had been in Silver City only a short time. It was said by informant Kitt Conn that Dora and William Young were "gettin' kinda thick."

Henry, a wealthy farmer, was well liked in the community and quickly became friends with his neighbors, who missed him when he did not show

up in town as per his usual routine. Sheriff Harvey Whitehill followed his own hunch and in February 1879 went to the farm to investigate. Citing his reason for arriving at the farm as a normal welfare check on the family, Whitehill became suspicious as he questioned Dwenger's young wife.

Dora told the sheriff with all sincerity that her husband was on an extended trip to Missouri to visit his family. The story sent up red flags in the sheriff's mind—not only did most of Henry's family live in Indiana, but also there was no livestock missing from the farm. It would be difficult for the man to walk all the way to Missouri from New Mexico, if that was indeed where he was headed.

Whitehill, determined to get to the truth of the matter, went back to the farm to question Henry's son William. When the sheriff arrived at the farmhouse, he found Dora, William and Young in bed together. Under the same bed was found a sack that, according to his report, was filled "with the old man's gory clothes, which Dora had chopped into pieces." William would tell a chillingly different story than that of his stepmother.

The young Dwenger confessed that he had killed his father with a needle gun on November 17, 1878, while Young stood by with a revolver just in case the first weapon failed to complete the task. This, he also admitted, was at the urging of "his mother," Dora. The entire plot was schemed by Dora and Young, who coaxed William into participating.

Lured by the boy's false promise of a good mining hole in the mountains between the towns of Hanover and Georgetown, Henry Dwenger met his fate when he had the misfortune of turning his back on his son and friend. After the killing, he was stripped of his clothing and unceremoniously buried in an unmarked grave. William recounted that Dora had given them a sack to take along with them to collect Henry's clothes. Dora was said to have been pleased with the outcome.

When asked in court why she sent the sack along with the boys, Dora coolly replied, "There was a similar case in Germany where the person was identified only by his clothes."

Clearly, Dora was hoping Henry would remain missing for a long time.

Once the gruesome task was complete, the three divided Henry's worldly goods, which amounted to about $5,000 each, and continued to live together until arrested. Dora and Young had big plans for their shares. They would go away together, find a nice quiet place to settle down and enjoy the spoils. One has to wonder, if they had not been caught, would William Young have been Dora's next victim?

Sheriff Whitehill had Dwenger's body exhumed. It was found that he had been shot in the back of the head, with the bullet exiting through the right eye. With this evidence, the trio was arrested on February 28, 1879, and taken to the Grant County jail to await the decision of the grand jury, which would meet on July 16 of that same year. An indictment was reached quickly.

In the meantime, Sheriff Whitehill was appointed administrator for Henry's estate and took the youngest son, Josie, home to Fort Wayne, Indiana, so that he could be returned to his rightful family members. Henry's brother, Bishop Dwenger, a highly respected community member, was said to have been anxiously awaiting his nephew's arrival in Indianapolis. (A sad side note is the fact that the nine-year-old Josie, now an orphan, must have witnessed at least part of the horrible crime, as he was able to give a graphic account of this father's murder to the sheriff.)

It was during this trip that Dora's story took another odd twist. Whitehill bragged to a reporter for the *Missouri Republican* that he had the infamous Kate Bender in custody in Silver City. Apparently, Dora had told the sheriff that her real name was Kate and was able to recount many stories involving Bender. She was also about the same age, complexion and build as the famous murderess. On learning this, the sheriff deduced that Bender had taken up her profession in Silver City under an assumed name.

As the reporter questioned Whitehill's claims, he asked for proof. The sheriff was quick to state that a man who had been a classmate of Kate Bender in Kansas came to the Grant County jail to have a look at Dora. He verified that Dora was indeed Kate Bender even though Dora showed no indication of recognizing the man.

The story was a national sensation. Kate Bender had vanished over six years earlier, and one of her last sightings was reported in El Paso, Texas, which is

No known photographs exist of the murderess Dora Dwenger, but she was reported to bear a striking likeness to Kate Bender. *Library of Congress.*

close to Silver City. Had the mystery finally been solved? In Whitehill's mind, it certainly had, and he showed Dora's photograph to the reporter as evidence. According to the reporter's article, the woman staring back at him was in her mid-thirties and had "a full, heavy face, large lower jaw, very small eyes and the mouth of a virago." In Grant County court documents, Dora is described as a heavyset woman of about five feet, three inches, with light hair, gray eyes and a light complexion.

On September 5, 1879, the *Evansville Courier and Press* out of Evansville, Indiana, ran a story out of Little Rock, Arkansas, that refuted Sheriff Whitehill's bold claims: "[Sheriff Whitehill] is on the wrong scent. The following statements will prove that. Joseph Sprall, the former husband of the said Mrs. Dwenger, resides in this city, and says he married Dora Hesser in Dayton, Ohio, in 1868 and moved with her in 1870 to this place. They lived here [Little Rock] during the period of the Bender tragedies. In 1871, he obtained a divorce from her on the grounds of abandonment."

The story faded away after this account, but it is said that Sheriff Whitehill went to his grave thinking that Dora was indeed Kate Bender. Nothing is written of Dora's adventures between the years 1871 and 1878, when she met Henry Dwenger, but over $500 worth of silverware marked "Gaits House, Kentucky" was found in her possession when she was arrested. It is thought she made her living as a domestic in several hotels around the country, including the Gaits House.

Doña Ana County was the venue for the trial of the century. People packed the courtroom to catch a glimpse of Dora and her men as they testified and pleaded for their lives. Young claimed insanity, the affliction the result of an old injury that had resulted in a silver plate being inserted into his skull, giving him the nickname of "Silver Plate Dick." William swore that his father was a cruel man, which is why he was forced to kill him. There is no record of Dora speaking for herself in court.

The trial ended on April 12, 1880, and saw convictions of second-degree murder for William, who received a life sentence; fifth-degree murder for Dora, who was sentenced to ten years in prison; and first-degree murder for Young, who was sentenced to hang on May 14, 1880. Dora showed no emotion as Young's sentence was issued. Many in the courtroom described her as having a "cold-blooded stare."

Although Sheriff Whitehill was not thrilled with the idea of being ordered to hang a crazy man, he noted that "any mental diminishment Young suffered should not negate the court's remedy." The newspapers wrote of vigilante groups formed against Young, one of which had the "avowed purpose, in

the event that this defendant should be acquitted, to take his life to appease the vengeance of the citizens of Grant County." But the citizens would not have to issue their own justice, as William "Parson" Young was hanged on March 25, 1881. After an autopsy, it was discovered that Young had lied about having a plate in his head—much to the relief of Sheriff Whitehill. He was, however, found to have an extraordinarily thick skull. Young was buried facedown in his coffin.

Since it was found that Dora's only real participation in the murder act was giving the boys a sack, she was given a much lighter sentence. In the January 22, 1881 court records of *The Territory v. Dora Dwenger*, it is written, "Human life is not at stake here; unfortunately, the law does not permit her being hanged. Justice has only failed in this case by the law providing too light a punishment."

Since the Territory of New Mexico did not have a penal institution in place until 1885, prisoners were sent to the Kansas State Prison to complete their terms. While awaiting her transfer, Dora contacted other prisoners in the Doña Ana County jail. She struck up a fast friendship with fellow prisoner Richard Remine, who was also incarcerated for a heinous murder.

Remine had had issues with his partner and housemate, Patrick Rafferty, a fellow miner and a survivor of the Light Brigade of the Six Hundred. One night in March 1877, Remine found Patrick lying horizontally on the only bed in their cabin after he returned home from a night of heavy drinking. Not in a generous mood at that moment, Remine took his "single-jack, short-handled, mining sledgehammer" to Patrick's head and, when he was sure he was dead, dismembered the body with an axe. Exhausted from his handiwork, Remine curled up on the bed, amidst the gruesome sheets, and fell asleep. This is where he was found passed out the next morning and immediately placed under arrest.

With like minds, Dora and Remine became close friends, meeting often in the common courtyard at the prison. The newspaper suggested that they "plotted, jested, swore and cried" as they told each other their sordid stories.

Dora had worked her charm on Remine so well that when he had a chance to escape, which was every night, he stayed because of her. State jail records indicate that Dora had "got knocked up" in prison, and many believed Remine to be the father, although there are no indications in the records of a baby being born.

Due to the four-year delay of his case, many felt Remine would escape the death penalty. He was made a trustee by Sheriff Whitehill and would

perform small tasks around the jail, such as cleaning and picking up food from local restaurants and delivering it to the inmates. He was even allowed to visit the local saloons at night, where he would drink and gamble as long as he was back by eleven o'clock. One night, Whitehill scolded Remine for returning to jail too late and told him that next time he would come back to find the jail locked—apparently the sheriff thought it "too much trouble to open the jail at that late of an hour."

Ultimately, the missed escape opportunities and his love for Dora cost Remine his life. A message arrived concerning Remine's fate—he was to be executed on March 14, 1881. His hanging would occur only days before that of Dora's other love interest, William "Parson" Young. There are no accounts of Dora's reactions to losing these two men.

In April 1882, Dora and Henry's son William were sent to the Kansas State Prison, where Dora would serve only four years before her sentence was suspended by Governor Edmund G. Ross—but only if she agreed to not set foot in New Mexico for the remainder of her sentence. Dora complied and was never heard of again in New Mexico, at least not under any of her known aliases.

Before his transfer to Kansas, William escaped the Grant County jail. For unknown reasons, Governor Ross extended the same courtesy to William, who was the actual triggerman but somehow did not receive the same fate as his friend Young.

This drew a close to what was described as one of the most horrendous murders in Sierra County history.

Bronco Sue:
New Mexico's First Serial Man Killer?

To hear Susan Warfield, or Susie, as she was sometimes called, described by newspapers and accounts of those who knew her, one would never think that the blond, petite slip of a girl was capable of creating such havoc in at least three western territories. Starting her career in Nevada, Susie enjoyed a lucrative living as a cattle rancher whose herd mysteriously grew more quickly than the normal rates. Rumors of cattle rustling followed Susan wherever she traveled in the West.

Susie and her brother Joseph arrived in Forest City, California, after coming to America from New South Wales, Australia (a former penal colony), where she was born on September 11, 1844. Their parents had moved the family to America so they could work in the American mining town. It was here that Susie acquired her skills in riding and shooting and learned her array of colorful language from the miners who took a shine to her.

Newspapers would brag about Susie's skills by printing things like: "She can shoot a pistol like a sportsman and ride a mustang like an old-time vaquero."

It was also there that the fifteen-year-old Susie would meet her first husband, Thomas D. Raper (or Rapier, as it has been spelled in early articles), who worked at and eventually owned a stake in the Live Yankee Mining Co. The thirteen-year age difference did not seem to matter to the young Susie when they were married on March 6, 1860. It was speculated early on that Susie was more attracted to Thomas's fortune of $12,000 and mine ownership than the man himself.

In a short time, Susie became the mother of three sons—Joseph in 1861, Robert in 1863 and William in 1864—who would play a large part in her later behavior.

Beginning with the Snake Conflict, which lasted from 1864 to 1868, the Indian Wars were becoming more and more of a problem in the California/Nevada region, and raids were happening quite often. Isolation made farmers and ranchers easy prey for the Paiute raiding parties. It was during one such raid that Susie's brother, Joseph Warfield, was mortally wounded on July 26, 1865, in Willow Point.

In another raid, in Guano Valley on March 7, 1866, Susie's husband was shot. Some accounts hint at the fact that he accidentally shot himself in the arm as he was trying to get his weapon out of its holster. Regardless, Susie

Humboldt, Nevada, was Bronco Sue's original stomping ground. *Library of Congress.*

was left to defend her family and herself from the marauders, which she did in grand style and without hesitation, killing two in the process. Susie then strapped her wounded husband on his horse and took him back to Camp Dun Glen for safety and medical attention. (The Nevada Volunteer Cavalry had been stationed at the camp to combat the warring tribes and to do the best it could to protect the settlers.) The incident would leave Thomas permanently disabled and unable to work on their small farm.

Afterward, the family headed south to the community of Unionville. It was here that Susie found a teamster to take her young family out of harm's way. Authors Karen Holliday Tanner and John D. Tanner write, "According to Winnemucca's *Silver State* daily newspaper, the teamster had five or six yoke of cattle and a regular freighting outfit, and Susie hadn't a dollar, but before they reached California, Susie owned the team, left her husband, and returned to Humboldt County." Susie seemed to love Thomas, but she had grown tired of playing nursemaid for him—besides, his money was gone as well. There would be no divorce between the couple, but Susie had already set her sights on Captain Robert C. Payne of the Nevada Volunteers while they were at Camp Dun Glen. Apparently, she thought him to be a better prospect than a man with the use of only one arm.

The captain had an honorable military career and was discharged on November 18, 1865, at which point he took up with Susie. Payne also partnered with James Russell and John Palmer, a Carlin justice of the peace, as owners of a stage line that ran over the White Pine Toll Road. This was the first toll road in Nevada and ran from Elko to the new boomtown of Hamilton. The White Mountain mining district exploded due to a huge silver deposit found in the area, and money was made hand over fist as a multitude of people used this road to get to the mining fields. Carlin became know as the town "where the train stops and the Gold Rush begins."

In the 1870 census, a twenty-six-year-old Susie is listed as a dressmaker living with her young boys. Susie worked for Kentucky socialite Carrie Taylor, an adventuresome woman in her own right who shocked her counterparts by moving to the Wild West. This was also the time when Susie aspired to become independently wealthy by going into the cattle business. It was a great idea, and she was a natural—the only problem was that they were not her cattle.

Susie knew no boundaries; if she wanted it, she got it—no matter the methods.

Carrie Taylor was good to Susie, having given the young woman an honest job in a hard environment. But Susie repaid this kindness by relieving her employer's jewel box of some of its weight. With too many literal irons in

the fire, Susie was accused of grand larceny in the theft of the gems and the cattle, being caught red-handed on more than one occasion with a branding iron adding embellishment to the steer's existing brand.

Charles Edmond "Charley" Smith, one of Susie and Robert Payne's former employees, spread rumors like wildfire about his former boss being the ringmaster for a group of rustlers. This caused Sue to flee. After four days, lawmen caught up with her, and she put up a valiant effort of resistance in Austin, Nevada. Her accomplices, Eli Gibson and John Barry, were also eventually arrested.

However, with a bat of her lashes over her doe eyes, the judge and jury granted Susie's freedom with not much more than a "Now don't do that again, little lady." Susie was an expert at manipulation, using her "true womanhood" as part of her "petticoat defense." She was so successful, in fact, that she earned three acquittals for larceny in 1870 alone. She shamelessly used her sons or other children, rented for five dollars a day, as a pity ploy, which worked wonderfully. One of the male jurors confessed that he "had a hard time convicting a woman." This sentiment would be a common thread in most of Susie's future run-ins with the law. During these trials, local newspapers began referring to Susie as "Bronco Sue," "Buckskin Sue" or "Six-Shooter Sal." She had become a media darling, and she had an extensive profane vocabulary to match her personality.

Elko had become too hot, and soon it was time to move once again. So Susie uprooted her family and moved to nearby Carlin, where she ran an advertisement in the paper stating her intentions to start cattle and horse ranching in her own name and on her own account. The court approved the application, thus allowing Bronco Sue to become one of the largest cattle and horse ranchers in Nevada.

Sue's horses became known for their quality, and people would arrive at her door to purchase them, mostly to be used in racing. It is not known if these were actually Bronco Sue's horses or if they had been delicately borrowed from neighboring ranches.

A well-known story tells of Sue's favorite horse being confiscated in order to satisfy fines she owed. When she returned and found it missing, she immediately went to the livery stable where the steed was taken. With a smile and a bat of her lashes, Sue was able to distract the attendant long enough to mount the animal bareback and tear through town with, as the locals described it, "a fair amount of well-turned leg exposed." The sheriff and a few other men made chase and, after great difficulty, finally caught up with the furious woman and took her into custody.

One of the most difficult stories regarding Sue's history was the fact that she relinquished her young sons Joseph and Robert to the Nevada Orphan's Home in Carson City on March 23, 1871. Their brother William would follow on April 25. Although not much is known of her intentions, it's apparent that Sue's maternal instincts were not well developed.

Legend holds that Sue and Robert Payne then headed to Indian Territory in Oklahoma, where Sue began trading beeves with the local tribes for a short time. Trouble apparently followed Sue to Oklahoma, as there are stories indicating that her trades with the tribes were not quite legitimate.

Payne was arrested for larceny and sent to prison in April 1874, but Sue did not wait around for him to get out. Instead, she moved to Alamosa, Colorado, where she would be known as Susan Stone. She would own the stage line between Conjos and San Antonio, New Mexico, during this time and would also meet and marry Jacob "Jack" Younkers, or Younckers, as it is sometimes spelled. After the marriage, the couple moved to Rio Arriba County and set up a tavern in Wallace, which they ran for a short time.

The Younkerses heard about the boomtown of White Oaks in Lincoln County and decided that there were greener pastures in the gold fields. Two accounts of their journey have been told. According to one account, the couple made it to White Oaks and set up a cabin, where Jack contracted smallpox and died, leaving Sue to bury him. Sue's version, however, is much different. According to her, Jack contracted the disease (even though there were no reported cases of smallpox in New Mexico at this time) while on the road, leaving her the task of burying him near Alkali Wells. Robert Black, a rancher in the White Sands area, happened upon her and helped her bury her husband. Black would follow Sue to White Oaks.

Black would marry Sue, and the couple would then move to Socorro, where they set up a saloon and boardinghouse. Sue ultimately convinced her new husband to sell off his cattle and sign over his property to her. Sue used the money from the sale of the cattle to open and run her boardinghouse, while her husband's saloon ran into financial trouble, forcing him to close.

Without money, Black was no longer any use to Sue, who proceeded to kick him out of the house after a heated argument. Black vowed he would get revenge on Sue when he returned. Hearing this and believing her life was in danger, Sue went to the sheriff and reported his threats.

The sheriff knew what kind of shot Sue was, and he warned Black to stay away. He also informed the local merchants not to sell any weapons to Sue. Sue did indeed go to one of the merchants to purchase a pistol, and

when she left, the merchant explained, rather proudly, that he had sold the weapon to her but had given her the wrong ammunition so that it could not be used.

As predicted, a drunken Black showed back up at Sue's demanding to be let back into the house. And although Sue's pistol had been sabotaged, he met the wrong end of Sue's rifle and lost his life instead. Sue claimed self-defense, stating that Black had come at her with an axe and that she was forced to take action. Although no charges were filed at this time, Sue was ultimately indicted for murder. Upon learning of her impending arrest, she escaped to Doña Ana County. For reasons unknown, Sue's sons William and Joseph Raper were arrested instead. William plea-bargained out of the charges and later joined his mother.

Records indicate that Sue married A.R. Booth in 1878, but not much is known about this union or its outcome.

In La Luz, Sue met and married Charley Dawson in 1885. This relationship would not turn out any better for Charley than it had for the rest of the men in Bronco Sue's life. When Charley found out that Sue was having an affair with their married neighbor, John Good, he challenged

A typical frontier home in the Sacramento Mountains in Lincoln County, New Mexico. It was in these mountains that Bronco Sue was rumored to have been shot and killed. *Author's collection.*

Good to a duel in the street. Being the better shot, Mr. Good survived but was promptly arrested.

As the grieving widow, Sue attended Good's hearing and was recognized and arrested for Black's death. During her trial in 1886, the local newspapers referred to Sue as the "Lucretia Borgia of the West." Once again, a bat of her lashes and a few crocodile tears was all it took to get a not-guilty verdict. William Raper testified against his mother before the grand jury, creating a stir. As he spoke, Sue reportedly had tears streaming down her cheeks. When asked if his statements were true, she stated, "I do not want to help make my son a perjurer—he is my boy." William's actions nearly got him lynched, but his mother pleaded for his release.

Following his brush with the law, William was arrested and jailed once again on the charge of robbing his mother of approximately $1,000 in jewelry in 1887.

Days after her release, Bronco Sue reportedly left New Mexico, after selling her lot in White Oaks for fifty dollars, for Arizona, never to be seen in New Mexico again. Legend also states that Bronco Sue was killed in a horse-rustling attempt in Lincoln County. Only history knows her fate.

Valentina Madrid and Alma Lyons:
Partners in a Crime of Passion

Valentina Barilla was the perfect example of the reason some people should not get married at an early age. Being only fifteen at the time of her marriage to Hillsboro, New Mexico business owner Manuel Madrid, this lack of maturity would play a huge factor in the events that would change at least three people's lives in major ways.

Manuel Madrid, also known as Pedro, was described as a hardworking, pleasant man from a good family who had moved from Mexico to the mountain community of Hillsboro in the central part of the New Mexico Territory. Several years older than his bride, Manuel purchased a home for them in the sleepy town and began to settle in.

Valentina, who was born in Mimbres, New Mexico, was described as a woman of beauty who had quickly captured Manuel's heart. For some women, the idea of being married is far more romantic than the reality, and unfortunately for Manuel, this would also be the case for his young bride.

Manuel provided Valentina with a beautiful home, into which she moved her childhood friend Alma Lyons. Alma, described in the newspapers as a "girl of color," was hired to help Valentina clean and to provide her with moral support. Manuel had hoped Alma would become a good influence on Valentina as a maid and friend, but the young girl's beauty and flirty ways had also attracted the not so welcome attention of other men on the farm.

When the giggly Valentina caught the eye of Francisco Baca, a worker on Manuel's farm, infatuation grew quickly for the girl. With Alma's help, the two were able to meet in secret. Baca would stroke the young girl's ego by

telling her of his great love for her and how happy they would be if only she were not married to the old man. Valentina quickly became disenchanted with her marriage, as she was deeply in love with her secret lover.

Manuel became suspicious of Baca and his wife of two years. He warned Baca, originally from Arrey, New Mexico, to stay away from his wife, and the girls were put on notice as well. This did not sit well with Baca, who used treachery to manipulate the women into following a devious plan that would result in the death of one man and ruin the lives of two women. But as the old saying goes, "Love is blind."

Baca convinced the women that the only way for him and Valentina to be together and share their amazing love was to make her a widow. With this,

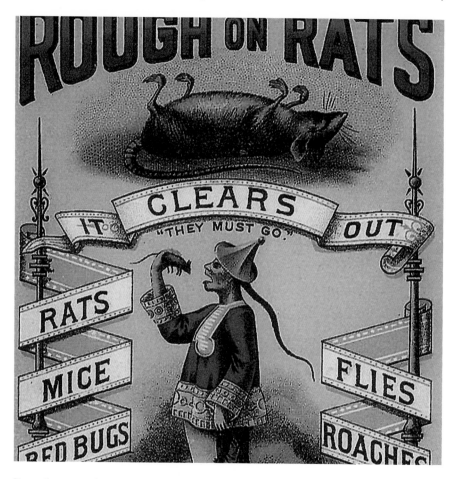

Rat poison caused an enormous amount of grief for all involved in one of the most sensational crimes in New Mexico's history. *Library of Congress.*

Valentina would become a very rich woman and would be free to marry her true love.

One can imagine how easily Baca, with visions of dollar signs flashing before his eyes, could manipulate the young girl to his way of thinking. Alma, wanting to see her friend happy, went along with the plot and proved to be a good friend to Valentina, even in the event of a horrible crime.

Armed with the money given to her by Valentina and Baca, Alma traveled to the mercantile to make her deadly purchase. The Rough on Rats rat poison would live up to its name, also proving that it was equally rough on humans. Valentina had a last-minute change of heart, only to be persuaded by Baca that she was doing the right thing.

The following morning, Valentina carefully mixed in lethal doses of the poison, proportioned by Alma, with Manuel's morning coffee. Within days, the concoction had done its dastardly job, and Manuel was bedridden with horrible stomach pain. His bride remained dutifully by his side, quietly tending to him as he suffered agonizing, unexplained pain.

Manuel succumbed to death on March 30, 1907, and if it had not been for his brother calling Dr. Frank I. Given to examine the body on the deathbed, the death would have been attributed to normal causes. Thanks to Dr. Given's discovery of the poison, however, the alleged murder was treated as such.

When the doctor's report was taken to a coroner's jury, the findings incriminated the young bride and her childhood companion of murder. As the two testified in front of the justice of the peace in Hillsboro, they broke down in a tearful confession while also bringing a third party into the mix—Valentina's lover, Francisco Baca. All three were to become inmates at the Sierra County jail while awaiting the next district court session, which was to be held in May. While Manuel's funeral service was being held, it is reported that Valentina experienced seizures, pain and shock in her jail cell.

Due to the many twists of the case, the public—both local and national—soon began to drink in the sensation of the scandalous crime. It seemed everyone had an opinion on this trio, who were now high-profile celebrities. The Sierra County Grand Jury was not impressed and indicted them all for first-degree murder. At the arraignment, Judge Frank W. Parker and the New Mexico District Court heard three not-guilty pleas from the accused.

For reasons not given, Judge Parker decided to try Baca separately from the girls, holding his trial until the following term. Due to death threats from vigilantes, Baca was whisked away to the newly opened territorial penitentiary in Santa Fe, where he would be much safer.

Attorney James R. Waddill of Deming was assigned to defend Valentina and Alma, with Judge Parker telling him it would be "a difficult and unpleasant task." Considering the girls' joint confessions and the evidence that was collected in the case, there was no chance of them walking free. Valentina's fate was sealed when she made the following statement in court: "We walked to the cemetery, my husband and I, after I had given him his first dose of the rat poison, and there I playfully asked him where he would prefer to be buried."

The newspapers described the pair as "weak-minded and moral degenerates" going through the trial while acting like they did not have a care in the world. This behavior did not sit well with the jury or those

Hidden in the mountains, Hillsboro was a perfect place in which to hide or commit crimes. If the ruins of the Hillsboro Courthouse could talk, they would tell a fantastic tale. *Library of Congress.*

attending the trial. When the trial concluded on May 9, it took the jury less than an hour to render a not-so-surprising verdict of guilty of murder in the first degree. Their sentencing would be held the following morning.

The May 25, 1907 *Albuquerque Journal* wrote of the crime, "Girls doomed for murder may escape gallows. The strong feeling in Hillsboro [is] that hanging of women would be a disgrace despite the heinousness of the crime. Prisoners are young and so densely ignorant that it is scarcely possible they realize the enormity of the offense."

Judge Parker, who was described as a kind-hearted man, was not accustomed to sentencing women. He gave them one more chance to save themselves when he asked if they had anything further to add. Both women upheld the confession but added that they had committed the act under duress, stating that the only reason they went through with the murder was because they feared for their own lives. They stated that a controlling Baca had devised the evil plot and threatened to kill them if they did not follow through on their side of the bargain.

Although the judge was a compassionate man, he was compelled to pass a harsh sentence on the two girls. The crime was too great, carried out with callousness and in a cold-hearted manner. The only recourse was to give the highest sentence allowable for such a heinous crime: death by hanging.

According to court documents, Judge Parker had the following to say to Valentina: "The law demands of all people that they exercise judgment and lead a correct moral life. The fact that some man told you to do this excuses not one particle of guilt. You have committed the highest crime known to the law and took advantage of the confidence and affection which your husband reposed in you and sent him to his grave as you would a dog."

Toward Alma Lyons, the judge showed empathy in his statement: "I appreciate something of the circumstances under which you were born and reared. I have seen you as a small child walking around the streets of this town. I know you have never had such care and training as you should have had, and that makes me doubly sorry for you, but the law must be enforced. You have been a party to the most outrageous crime that has ever been known in this part of the country."

Alma's story was tragic, and the judge wanted to show her sympathy, but the law would not allow him the luxury. Alma's mother had died when she was a small child, and her father, who worked as a miner to make a living for his family, was absent for most of her life. Records show that Alma raised both herself and her younger brother on her own for years without much help from her father or the community. Money was nonexistent, so she did

what she had to do to survive. The thought of going to school was forgotten, leaving Alma illiterate and regarded as a person with a very low intelligence. All accounts of Alma described her as a "wild child."

The friends would face death together, as they were sentenced to be hanged on the courthouse lawn between the hours of 9:00 a.m. and 4:00 p.m. on June 7, 1907.

The *Sierra County Advocate*, Hillsboro's newspaper, was having a field day with the case. It would state its disgust with the case and the "wickedness of the dreadful crime" but, almost in the same breath, would say that the hanging of the girls would be "a disgrace to the territory, and especially to Sierra County."

Public outcries reached Santa Fe, and the fate of the girls would rest on the shoulders of the acting governor of the Territory of New Mexico, James W. Raynolds. One of the largest proponents for the death of the girls would be Dr. Frank Given, the doctor who had first discovered the crime.

In letters written to Raynolds, Dr. Given states that Alma played a larger role than she was letting on, claiming that she was "experienced in how much dosage of poison to be given." During his interview of Alma, Dr. Given noted that she could give the effects of poison on a person and the related symptoms as well as "any new graduate in medicine would relate." He wondered how this illiterate girl could have this amazing ability if she had not used it in the past.

The doctor observed that while Valentina seemed remorseful for her part in her husband's death, Alma seemed to be oblivious to the severity of the situation, as she "grinned and laughed" when they left the courtroom on the way to their jail cell.

Calls for the girls' sentences to be commuted from death to life in prison came from newspapers and civic leaders—even the Sierra County undersheriff, Julian Chávez, testified that he had watched the girls in their cell "playing and giggling like children of eight or ten years old," causing him to believe that they were not of average intelligence.

The deciding plea may have come from Henry Lyons, Alma's father, who traveled to Santa Fe from Colorado, where he had been working, to beg for his daughter's life. Unaware of the trouble his daughter was in at first, being so far away from Hillsboro, Mr. Lyons made his journey as soon as he was informed of his daughter's fate. With a bowed head, standing before Acting Governor Raynolds, he told Alma's heart-rending story with tears streaming down his face. "Alma grew up without a proper upbringing and in complete ignorance of everything," he said. It was

Henry Lyons's plea that their sentence be commuted so that they both could "learn the way of righteousness, and the fear of God, and the laws of mankind." Mr. Lyons left this meeting with no more indication of Alma's future than when he had arrived.

Raynolds was no doubt tortured by the implications of this hanging and was known to have sought out counsel from many important New Mexicans, who gave him a wide variety of opinions. His decision would be announced without rashness, having completely weighed both sides. The girls had been described as being of below average intelligence and therefore unable to make rational decisions on their own. Judge Park had categorized the women as "young, ignorant and immoral to a degree."

Three days prior to the execution day, the morning of June 4, 1907, dawned with a nervous executioner sending a wire to Raynolds begging to know whether to begin construction of the gallows. Work began on the wooden structure, which was within view of the condemned jail cell, as no word was received. By late morning, Sierra County Commissioner Trujillo received word that the sentences would be commuted, and work immediately ceased.

It is said that the only reason the girls were spared was so they could testify against Francisco Baca, whom Raynolds believed was the brains behind the operation.

On June 7, which had originally been their scheduled execution day, Valentina and Alma were on a train bound for the New Mexico Territorial Penitentiary to commence their life sentences. Escorted by Sierra County sheriff Eduardo Tafoya, the prisoners were described as "cool and collected" as they entered the gates at the imposing brick prison.

Francisco Baca had already been at the prison for what was described as "safekeeping," his trial having been postponed until May 1908. Two mounted police officers escorted all three prisoners back to Hillsboro for the sensational trial.

According to local newspapers, the girls had matured in prison and seemed to be doing better than before, which proved well for the prosecution, as they were the chief witnesses against Baca. During his supposed "true love's" trial, Baca was silent as a stone, but during his own, he denied each allegation with vigor. After all was said and done, the jury could not reach a verdict; therefore, a mistrial was declared. By the orders of the court, Baca was held at the Sierra County jail in lieu of $10,000 bail; a new trial would not be held until November 1909. However, this trial would also be postponed. The *Sierra County Advocate* wrote that it was

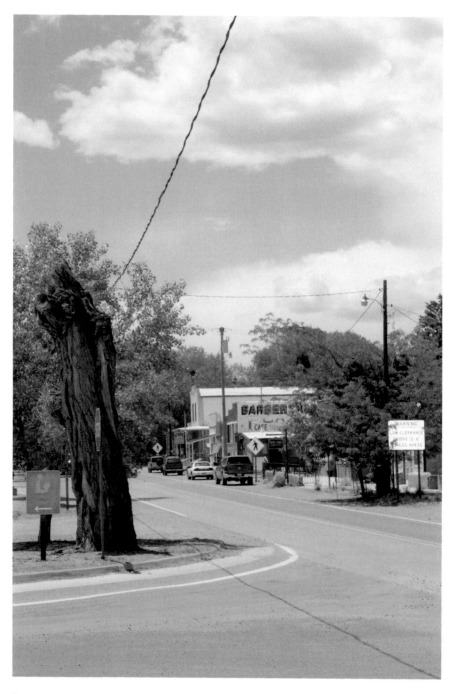

Present-day Hillsboro is not much different from its origins as a hotbed of mining activity. *Author's collection.*

costing the citizens of the county a fortune to house and feed Baca, who was becoming a "white elephant."

In May 1910, when the second trial finally did occur, Manuel Madrid had been dead for over three years. The women again made the long trek from Santa Fe to Hillsboro to repeat their testimony. This time, however, Baca's luck changed, as the jury found him not guilty. While the jury did feel he had manipulated and intimidated the girls, there was not enough evidence to convict him of the charge of first-degree murder.

As Baca was set free, Valentina and Alma were once again returned to the penitentiary.

Alma proved to be a model prisoner, and with that in mind, Superintendent John B. McManus brought her into his home as a domestic. It was in this home that Alma developed a relationship with prison trustee Juan Trujillo, who was in prison for three drunk-and-disorderly arrests, and became pregnant. When the pregnancy became apparent, prison authorities began damage control. A private adoption was set up for after the birth but was spoiled by the visit of Henry Lyons, Alma's father.

Mr. Lyons, on seeing his daughter's condition, wrote a letter to the governor demanding justice for his daughter, who had told him that after the prison found out about the pregnancy, it fed her only bread and water for three weeks. When confronted with the charges, Superintendent McManus denied any wrongdoing. After further interrogation, Alma eventually admitted that she had lied about her treatment.

On April 1, 1914, at St. Vincent's Hospital, Alma gave birth to a healthy baby boy, who was promptly taken away and adopted by a local family. Alma was returned to the pen on April 10. The child's father had been paroled the previous October, most likely oblivious to the fact he was a parent.

Both women applied for pardons in 1918 but were denied. Valentina cited that she had obtained gainful employment in Rio Arriba County and produced a petition signed by 125 citizens of Hillsboro, including Prosecutor Wolford, to have her released. On May 12, 1919, Governor Octaviano A. Larrazolo commuted their sentences from life to twenty-three years. Although the women had received a certain amount of celebrity at the time of the murder, on March 3, 1920, they stepped out of the penitentiary "to anonymity."

The conditions of the pardon were specific: they were not to leave New Mexico, they were to stay out of Sierra County and they were to have "honorable employment."

Valentina received a job on her brother's ranch near her family in Parkview and basically faded away into the fabric of life. In the 1920 census, Alma can be found going by the name of Gibson, but by 1930, she is found under the name Gaines in Santa Fe, where she is listed as a widow working as a cook and living with her elderly father, Frank; her brother; and her son, Michael Gibson.

The two girls who had committed this horrible crime left the prison as women with far more maturity and respect for human life.

Chapter 5

Ada Hulmes:
Territorial Nightingale

In the Old West, entertainers brought life and, in some cases, culture to a land where culture was an extremely rare commodity. In polite society, these entertainers were snubbed and thought of as one step above scammers and thieves.

A native of California, well-educated Ada Hulmes had a tarnished reputation as a saloon singer and piano player. Many whispered that she was a woman of ill repute, which may well have been the case—after all, travel and costumes cost a pretty penny in the late 1880s. Not to mention the fact that Ada was friends with several women who were known prostitutes.

After playing in several venues such as the Bacchus Saloon in El Paso, Texas, and in Prescott, Arizona, Ada turned her sights on Silver City, New Mexico, where a king's ransom of gold and copper had been taken out of the surrounding hills. Billboards called Ada the "Territorial Nightingale," as she could sing while accompanying herself on piano. In those days, most female piano players were relegated to the ladies' parlors of the ornate Victorian houses, not saloon floors.

Ada's father and brother died suddenly when she was a teenager, and her mother reportedly went insane, forcing Ada to marry to gain support for her family. This union produced a daughter for whom Ada became solely responsible after her abusive husband left them high and dry after squandering her estate. (Interestingly enough, there was no mention of a daughter in any reports until Ada's defense attorney divulged the fact in

The view of Silver City from La Capilla Hill, just south of town, gives a stunning overlook of the former boomtown. *Author's collection.*

court.) According to the New Mexico Office of the State Historian, Ada placed her daughter in a convent and worked to pay for the child's upkeep.

Silver City had enacted an ordinance that prohibited women from entering a saloon—so one ingenious saloon owner rolled the piano up to an open window and had Ada play from her seat on the front veranda. The ordinance was quickly abolished.

Ada became involved with a married monte dealer named John V. "Jack" Brown, known as "Black Jack" to local bar patrons. Described as a ladies' man and a scoundrel, Brown was a consummate flirt but cut such a dashing figure that the ladies would overlook his lecherous ways. He was known to wear five-dollar gold buttons down the sides of his pant legs and on his jacket. And while local newspapers described Brown as a "border rough, worthless fellow," Ada was not to fare any better, described by the same papers as "a notoriously fast woman and courtesan."

Ada was convinced Brown had eyes only for her—until she was proven wrong. And as with many of the other ladies in this book, her wrath was dealt with death.

The events that occurred on the chilly night of February 21, 1889, would make both national and international news. The papers would use Ada and

Jack's story as an example of what a woman scorned could do and warned men to take heed.

Despite the various spellings of her name, which include Hulmes, Hume and Humes, her story is the same: love gone wrong, a one-sided crush with a tragic ending. For the sake of consistency, the Hulmes spelling will be used in this volume.

The "Nightingale" was playing at Silver City's celebrated Monarch Saloon, and her love interest was at the Centennial Saloon across town. Gossip spread through the mining town about their relationship and the fact that they were living together, which probably led to a case of cold feet on the part of the philanthropic Jack. The *Silver City Enterprise* wrote details of the case; including the fact that Brown had written Ada a note to break off the affair, which did not sit well with Ada.

A surprised Ada begged Brown to reconsider by spending the evening with her, only to receive a curt note that, according to writers Karen and John Tanner, stated he "wished to break off all further familiarity." Insult was added to injury when a second note from Brown was delivered to Ada's lady-of-the-evening roommate, "Claude" Lewis, inviting her to meet him at the saloon.

Ada stewed for a few moments before grabbing a pistol, which she gingerly wrapped in a silk napkin before placing in the bodice of her dress. The enraged woman grabbed Claude and insisted she go with her to the Centennial Saloon, as she was going to "kill the son of a bitch."

Seeing the rage in her friend's eyes, Claude was taken aback. "If you are going to have any trouble, I will not go with you," she said. Ada responded with a determined, "I will not have any difficulty with him."

Brown was in the back gambling room of the saloon, unaware of the storm that was on its way to his door. As a carpenter and volunteer fire chief, Brown was a well-known and well-liked citizen who had his fingers on the pulse of the town, but he was not prepared for Ada Hulmes.

Wasting no time, Ada stormed to the card room where she knew Jack would be playing and announced, "I'm going to kill you, Jack Brown!" With the pistol drawn, Ada meant business. Instead of approaching Ada to calm her down, Brown hid behind a stove. Ada proved to be better at shooting than he was at hiding.

The police report stated that a single bullet had entered Jack's left side, ricocheted off a bone and exited through the right side of his chest. Brown mustered enough strength to make it outside, where he collapsed dead on the sidewalk.

Terrified of what she had done, Ada ran to the back of the saloon and was helped by laundress Savannah Randall, who spirited her away and hid her in one of the cribs behind the saloon.

Sheriff Harvey Whitehill and Deputies Al Card and Charles L. Cantley were called to the murder scene, where they eventually found Ada in the brothel after kicking in the door. According to Whitehill's statement, Ada was acting like a crazy woman, "swinging her arms and yelling like a hyena."

In a desperate plea, Ada claimed self-defense and momentary insanity, stating that she remembered none of the events that had occurred after reading Brown's note. When taken into custody, Ada gave the prison warden $30. She claimed that this was all she had left of the $3,000 worth of diamonds she had been known to possess. This proved to be untrue when she requested money from the diamonds to pay her attorney.

Ada's defense attorneys, Idus L. Fielder and Gideon D. Bantz, immediately requested a change of venue due to the volatile attitudes toward their client in Silver City. With that granted, famed attorney Albert J. Fountain joined the defense.

Held in Las Cruces, the highly attended five-day trial began on October 4, 1889, and concluded with a guilty verdict on October 9, 1889. The verdict was handed down by Judge John R. McFie, who was consistently described as a just, honest and competent judge.

Ada, who had remained stoic during the trial, broke down and cried hysterically after the verdict was read.

In an article entitled "Our Reporter Thinks" in the October 2, 1889 *Las Cruces Daily News*, the reporter sarcastically commented that "the Ada Hulmes case is attracting a great deal of interest. Some smutty points come up, but of course nobody takes any interest in them."

Judge McFie imposed a three-year sentence on Ada in the New Mexico State Penitentiary. Grant County is the only county to have sent a female to the penitentiary. The *New Mexican* newspaper out of Santa Fe ran a small blurb about the incarceration that read, in part, "There is a female cell on the third floor at the penitentiary, and this woman will be the second to occupy it." Also in this blurb was one of the first indications of an alternative spelling for Ada's last name: Humes. The newspapers would continue to bounce around on the spelling to the point where it became confusing. The first woman to occupy Ada's cell was Minnie Angel of Silver City, a convicted horse thief. Angel was sent to the penitentiary for one year but served only six months before being pardoned by Governor Ross in 1885.

Sheriff Harvey Whitehill was appointed to escort Ada to Santa Fe to begin her incarceration. Newspapers gave every detail of her arrival, her appearance, what she wore (a black silk dress, a black veiled hat and a fifty-inch sealskin coat that "set off her plump figure in the knobbiest of style") and the fact that she and the sheriff stayed at the Exchange Hotel, where she ate her last meal as a free woman. It all happened in much the same way that the paparazzi of today hound current celebrities.

Sheriff Whitehill told friends that Ada thanked him for the kindness he had shown her during her eight-month incarceration in the Grant County jail as she entered prison on October 30, 1889.

It did not take convict #324 long to stir up trouble from her fourteen-by fourteen-foot cell. Ada was soon in the headlines again, this time for a scandal that nearly brought down the prison authority along with her. The New Mexico newspapers had a field day with her story, claiming that Ada had not only one prison lover but two. Disgrace and outrage rocked the penitentiary to its core.

The May 16, 1890 edition of the *New Mexican*, relaying an investigation first published in the *Las Vegas Optic*, ran a small article concerning the beginnings of the scandal:

> *The* Las Vegas Optic *says, "…the people demand an investigation into John Griffin's charges anent certain penitentiary employees and their alleged sweet dalliance with good-looking Ada Humes." By the great hornspoon! Investigate say we also, and "let no guilty man escape." The* New Mexican *is informed from reliable authority that the charges by Griffin are absolutely groundless and false, but then "if the people demand an investigation," why, let them have it. It cannot hurt.*

Former penitentiary inmate John Griffin told the *Optic* that he had witnessed Ada entertaining while her original matron, Mrs. Clark, was away attending to her boss, the dying D.E. Abrahams. Charges were brought up against Deputy Warden J.M. Montoya and Steward L.E. Alared by J. Clancy, a prisoner who reported the alleged misconduct. The testimonies of former and current prisoners were discounted as hearsay and conspiracy.

The *Albuquerque Morning Democrat* ran the following comment in its February 21, 1891 edition: "That was quite a love affair in the territorial assignation house under the republican administration between Senator Perea's brother-in-law and Ada Humes."

Being the only woman in the territorial penitentiary, Ada was allowed certain luxuries not given to her male counterparts. These luxuries, rumored to include rugs, curtains, flowers, a soft bed and even a piano to help her adjust to prison life (not to mention a prison matron, who was paid a whopping sixty dollars to tend her), angered the local press, who were determined to find out if there was any truth to the rumors.

The prison authorities insisted that Ada was wearing dresses made out of gray prison material and received no privileges at all. They did concede that Ada received thirty dollars a month and that there was a piano in the penitentiary, but it was not paid for by the prison—Ada rented it on her own. Always cunning, Ada was quoted as saying, "Without the piano, I would become a raving lunatic in two months' time."

"Ada had a piano and two rooms, while six Native women were huddled together in one room," claimed the *Santa Fe New Mexican* in its "Penitentiary Report," which it printed regularly in the paper. The paper went on to make the following contradictory statement: "She was the only female inmate and was nervous and excitable; there was nothing to occupy her time, so the piano helped. She had books, flowers and pictures neatly kept in her room."

Even with the comforts afforded her, Ada's time in prison reportedly was not kind to her, as the status of her health began to decline and became a concern. This set in motion a master plan by Ada to get released. A call for doctors to be brought in to examine the murderess came from the media as well. The matron, Mrs. H.F. Swope, relayed that Ada spent most of her time crying, which concerned the authorities; it did not look well on the facility for its star prisoner to be ailing.

Ada's only view of the city and civilization was through heavily grated windows that faced east. Mrs. Swope relayed that Ada would sit and stare longingly out this window for hours at a time. The prisoner had penned several letters to Governor Prince requesting that he come visit her so that he could see firsthand how the prison environment had affected her. Her final plea was one of desperation, stating that she needed to "secure her child's future." Each plea was declined.

Ada knew her window of opportunity was closing and that she was becoming old news fast, so she had to devise another means in which to draw attention—fits of crying and hysteria would do the trick.

Given that Ada's reason for committing the murder was changed to insanity, three psychologists—Drs. Longwell, Symington and Sloan— were commissioned to examine her. After meeting with Ada, the doctors' conclusions were as follows:

Dr. Robert H. Longwell, the penitentiary's physician, wrote, "This woman is a nymphomaniac and has developed in the past month a suicidal mania and requires constant care and restraint. She is a physical and mental wreck. If she is not released soon, she will be a raving maniac with no hope of ultimate recovery."

Dr. John Symington, a consultant, concluded, "The woman is suffering from a severe nervous irritation amounting at times to a condition of hysteria, epilepsy and catalepsy. Physical condition is poor, emaciation quite marked."

Dr. J.H. Sloan's report was more extensive: "Condition has broken her health, and continuation will render her hopelessly insane. She is a sufferer from nymphomania and has spells of frenzy occurring with more frequency and greater violence all the time. We have enough insane people in our territory without deliberately making another one. When she entered prison, she weighed one hundred and sixty pounds; she now weighs one hundred and two with three suicide attempts."

Calls for Ada's pardon poured into the penitentiary from Silver City and other towns in southern New Mexico as early as December 27, 1890. Brown was being described as "universally despised," while Ada was "far more sinned against than sinning." Even the presiding judge expressed thoughts that Ada should never have been convicted.

One of Ada's most staunch opponents was Mary Teats, the head of the Woman's Christian Temperance Union, which was campaigning strongly to stamp out prostitution and alcohol during this time. The group came out in support of the court's decision condemning Hulmes, stating that Ada was "a danger and a contamination who wished to go back to her former wicked life."

Even with all of these pleas, Governor Bradford Prince refused to interfere—until he got the doctors' reports and a surprise request came to his office.

Edward Sheehan, a man who claimed to be Ada's estranged husband, arrived in Santa Fe on June 2, 1891, and begged that Ada be released for the sake of their daughter. The story Sheehan told was one of pity and redemption, and he promised Ada would change her ways so she could be with her daughter, whom she loved so much. The child was in Chicago waiting desperately for her mother's return. Sheehan stated that Ada's health problems would come to a halt if she were allowed to see her daughter.

This heartfelt plea pulled on the heartstrings of the authorities, who allowed Ada Hulmes to be pardoned on June 29, 1891, after less than two years.

Rage spread with the news of Ada's release. The *Las Vegas Optic* ranted, "The career of this woman, and the connection of some of the territorial

officials therewith, is one of the most remarkable and shameful pages in all the history of New Mexico. It is doubtful that its equal can be found in the civilized world."

It is not known whether the authorities knew of how Ada Hulmes, the supposed paragon of motherhood, spent her first night of freedom, but we can be sure that if they had seen her make an appearance in every dancehall and brothel in Santa Fe in the company of a twice-convicted horse thief, Alcario Dominguez, after her "husband" drank himself into a stupor, they might have thought twice about their decision.

Whether a daughter actually existed remains a mystery, as does what finally happened to the "Territorial Nightingale," who was last seen starring in a variety show a year later in Creede, Colorado. As with most of the ladies featured in this volume, Ada faded quietly into history.

PART II:
GAMBLING QUEENS

Lottie Deno:
Queen of the Pasteboards

L ottie Deno's father, a tobacco plantation owner, was also a gambler, and this would prove to be his daughter's salvation. The apple of her daddy's eye, Carlotta J. Thompkins, sometimes spelled Tompkins, born on April 21, 1844, would follow her father to purchase racehorses for their plantation and also to various gambling facilities around Warsaw, Kentucky, where he taught her the fine art of wagering and beating her opponents while remaining alarmingly calm. This was a shocking education for a young girl of gentle birth who attended the finest Episcopalian convent school for girls but would prove to be vital for her survival.

Her father could not have known that, through his training, his little girl would become known as the "Queen of the Pasteboards" in the height of her illustrious career and that all of his instructions would provide for the family he left behind after his death. He raised her to be strong and independent, not the typical southern belle of her day, which proved to be a saving grace for her in the years to come.

Cruel reality set in after Carlotta's father was killed in his first battle in the Civil War, rumored to have occurred while he was on board the CSS *Alabama*, where he fought for the Confederacy as a slave owner in 1862. Lottie, as her family called her, was the elder of two children and was sent to Detroit, Michigan, for the sole purpose of finding a rich husband, taking with her a good amount of what was left of the family fortune.

With her father gone and her mother ill, Lottie became the head of the household, and it was on her petite shoulders that the fate of the family fell.

Other family members were appalled that Lottie was now in charge of her father's estate, as this was unseemly for a woman in her times.

It is reported that Lottie did accomplish her goal, although she did not get married. Instead, she took up with one of her father's former jockeys and wealthy Boston businessman Johnny Golden. However, when it was revealed that Golden was a gambling associate of her father's and of Jewish descent—not to mention a Yankee—he was shunned by Lottie's mother and sister. While Lottie was with Golden, her family considered her an outcast as well.

At Golden's encouragement, Lottie began her gambling career on the riverboats on the Ohio and Mississippi Rivers. They traveled on the gambling boats together until 1863, when Golden left her and drifted out of her life, telling her he would meet up with her again in San Antonio, Texas.

While on the riverboats, Lottie was also accompanied by her nanny, Mary Poindexter, whose shocking seven-foot frame kept Lottie safe from any dangers that might come her way. Mary would sit behind Lottie as she gambled, watching each move with an eagle eye.

Mary, who was owned by Lottie's father and was eventually emancipated while in Lottie's company, was extremely loyal and protective of Lottie. While in New Orleans, on her way out west, an irate Union soldier accused Lottie of cheating and was just about strike her when Mary intervened and threw the soldier overboard into the Mississippi River. After word of this incident got around, Lottie was left with no worries of any uninvited attention.

It was also in New Orleans that Lottie met a fine southern gentleman from Georgia who was as handsome as he was deadly. Frank Thurmond's family owned the University Club where Lottie was working. The two met and took up a relationship that blossomed into something far greater than a business deal.

Part Cherokee, Thurmond was never without his bowie knife, which he carried in a sheath strapped to his back under his clothing. Should the occasion arise wherein he needed the weapon, all he had to do was reach up, and he was armed. It is said he taught this trick to his friend and infamous gambler Doc Holliday, who would get into some trouble when he tried to perform the maneuver.

On one occasion, a rowdy gambler charged Thurmond in his saloon, which proved to be a fatal mistake. Fearing that he would be arrested, Frank escaped New Orleans, leaving Lottie behind with the promise that they would meet again.

The redheaded beauty would continue to travel extensively for several more years, providing the means for her sister to remain in an expensive

boarding school after their mother's death while remaining a mystery to those who met her along the way. She was also searching for Frank as she made her way west, always hoping he would be at the next town.

During her travels, Lottie acquired several exotic nicknames that followed her around the country. One such nickname was "Mystic Maud," which she acquired at Fort Concho in 1870 because she was able to keep her business to herself, rarely talking to anyone. Others included the "Poker Queen" in Fort Griffin, Texas, and the "Queen of Cards" in other locations. No matter the moniker, Lottie was described by New Mexico author F. Stanley as "a strange one—cold as ice, warm as silk, silent as a passing ship."

It was in San Antonio that Johnny Golden reappeared. When Golden was around Lottie, she lost concentration and therefore lost her games. This did not sit well with the lady who was accustomed to winning numerous hands in a row. Johnny became possessive and often claimed that Lottie was his wife, which angered her. Good things did not happen to Lottie when Johnny was around, so Lottie made the decision to leave San Antonio and go farther west in search of Frank.

Mary had also faded out of Lottie's life while in San Antonio. Being an oddity, Mary had taken up with one of the many female gangs that roamed the town. Involved in violent street fights, Mary had found a place in which she belonged, a place where her skills would be an asset instead of a hindrance.

In Fort Concho, Texas, Lottie did not use her true name and was instead called Mystic Maud by the locals. But it was in Fort Griffin that Lottie Deno made her first appearance, and this name was to follow her for the rest of her gambling career. It is written that a drunken cowboy who had just witnessed Lottie's great skill exclaimed, "Honey, with winning like them, you oughta call yourself Lotsa Dinero." Lottie took the suggestion and shortened it to Deno, a name she would use in all the census rolls in Texas.

The redhead was so good at her trade behind the poker table that newspapers found it difficult to believe she was actually winning without cheating. One paper wrote, "The likelihood of a woman being able to win enough pots to make a living playing cards is far-fetched. That could only happen if she were crooked." It remains unknown whether Lottie ever cheated.

Not one for the social life, Lottie was said to live like a hermit in a cabin she rented on the edge of town. The cabin, which was basically a run-down shack, was furnished with expensive rugs and a large trunk that Lottie had brought with her from Jefferson, Texas. Fort Griffin townspeople were

curious about the beautiful loner and wanted to dig up some dirt, but the closest thing to dirt on Lottie was the fact that she played poker at the Bee Hive Saloon.

Fort Griffin's biggest attraction for Lottie was bartender Mike Fogerty, and the attraction was mutual. The two kept their relationship secret, especially since Fogerty was actually Frank Thurmond.

While playing faro and poker, her favorite card games, Lottie always kept her pistol on the table to discourage anyone from thinking she was an easy mark. Dressed in the height of fashion, Lottie conducted herself as a lady and did not allow foul language, alcohol or smoking at her table.

It was at the Bee Hive Saloon that Lottie was introduced to a gambler friend of Frank Thurmond, Doc Holliday. The gunslinger took a shine to Lottie and would spend most of his time at her table, occasionally losing upwards of $3,000 at a single sitting.

The saloon was also the alleged scene of a jealous altercation between Lottie and Doc Holliday's common-law wife, Mary Katherine Cummings, also known as "Big-Nose Kate." Holliday was forced to come between the two women in the middle of the catfight to prevent them from shooting each other.

According to a 1958 *Dallas Morning News* article written by Wayne Gard, Lottie Deno was included in a list of owners of bawdy houses along with Mollie McCabe, who paid $100 a year in fines—thought of as a license of sorts. This is possibly the only time Lottie was mentioned as being connected with the soiled doves of Fort Griffin.

A poem written by Fort Griffin pioneer Berta Hart Nance sums up the sentiments shared by the citizens of the fort toward Lottie:

> *My uncle was a Ranger*
> *In Old Fort Griffin days,*
> *And there he saw a woman*
> *He could not help but praise.*
> *You would not think to find her*
> *In a gambling den.*
> *Yet every night at poker*
> *She played with all the men.*
>
> *And no man dared insult her*
> *And no one knew her name;*
> *When she had won a fortune*
> *She vanished like a flame.*

Faro and monte were popular card games of the era. Fast paced and exciting, the games could make or break a gambler. *Library of Congress.*

Fort Griffin was hard on Lottie, as Johnny Golden caught up with her there and was killed in front of her. Lottie paid for the coffin and funeral but did not attend. Another incident found Lottie in the middle of a gunfight between two gamblers; as others dove for cover, Lottie reportedly sat calmly gathering her chips. When the sheriff told her he had never seen anyone so composed while chaos was ensuing, she looked him straight in the eye and said, "Obviously, Sheriff, you have never been a desperate woman."

Strength such as this made Lottie the subject of legend. She was immortalized as Faro Nell in a Dan Quin western novel written under the name Alfred Henry Lewis. She was also the inspiration behind the character of Missy Kitty in the 1960s television show *Gunsmoke* (coincidentally, the

saloon Frank Thurmond had in Kingston was also called the Long Branch Saloon) and Laura Denbo in the 1957 Leon Oris movie *Gunfight at the O.K. Corral.* Being a Native American, Frank was portrayed as Cherokee Hall in the Quin novels.

After five years, Lottie left Fort Griffin for the greener pastures of San Antonio, Texas, and soon became known as the "Angel of San Antonio." However, she would take her leave soon afterward to meet up with Frank in the mining boomtown of Kingston, New Mexico, in 1877. Precious metals in great quantities were being pulled out of the mountains surrounding Kingston, and the miners were hungry for entertainment. Lottie and Frank provided this with a small gambling room in the rear of their newly purchased Victorio Hotel. Lottie would serve as Frank's lookout during the gambling games at the Monarch, which was advertised as the "leading saloon of the Southwest." Lottie also owned the Broadway Restaurant in nearby Silver City. A liquor distribution business in Deming was also on the couple's résumé.

Luna County records indicate that Frank and Lottie were married on December 2, 1880, in Silver City. Lottie used her given name of Carlotta J. Thompkins on the marriage license. The Thurmonds were to make their home in Deming, New Mexico. In the years that followed, Frank would again make use of his bowie knife on his friend Dan Baxter, who threw a billiard ball at him, as he was known "to give ground to no one." Baxter's death was ruled a case of self-defense, but this was enough for Lottie, who had seen enough violence during her illustrious gambling career and made the decision to become respectable.

Lottie's quest for respect was realized as she became involved in many civic organizations—the very ones that would never have allowed her to attend had they known of her gambling background. One of Lottie's crowning glories was the establishment of the St. Luke's Episcopal Church in Deming. Parishioners might have fainted dead if they had known that the first $40,000 needed for the building was financed with poker winnings from a game with the notorious Doc Holliday. Some of the altar clothes for the new church were made by Lottie herself, and she took great pride in teaching Sunday school classes.

The ladies of the Golden Gossip Sewing Club, which Lottie started, would gather at Lottie's Deming home and swap recipes, sew quilts and play bridge. None of the ladies ever suspected it was anything more than pure luck that had Lottie winning nearly every hand with a sly smile.

Frank and Lottie would have forty years together before Frank succumbed to a malignant tumor in his nasal cavity in 1908. Lottie lived out the rest of

her years quietly without any of her neighbors suspecting the sensational past of one of the town's respected citizens. In reading her eulogy, the preacher said that Lottie led a "wonderful, devoted life" and that she "liv[ed] only to make friends."

After her death on February 9, 1934, Lottie was laid to rest beside her husband, with her headstone set a few inches behind Frank's left shoulder in what is known as the "lookout seat."

Carlotta J. Thompkins was born into a life of privilege, and through all of her trials, she remained a lady to the end—even if she did have to become one of the best gamblers of her era in order to survive.

Belle Siddons:
Lady Gambler and Spy

The sordid story of Belle Siddons is one of a young woman who was born into high society and raised to be a lady but fell from grace after suffering several tragedies.

Belle, a beautiful socialite and niece to the first governor of Missouri, was living the high life until the outbreak of the Civil War. As an honor graduate of the Female Seminary in Lexington, Kentucky, Belle was considered to be a highly educated woman, so she knew how to use her intelligence and beauty to manipulate people.

The young debutant fell head over heels in love with a journalist who just happened to be engaged to someone else. The man showed no interest at first, but like all others, he eventually succumbed to Belle's allure. When the war began, the need for men to fight was great, so the journalist went off to war, only to be killed in his very first battle. The news hit Belle hard, and she vowed to destroy every Yankee to avenge his death. Thus began the journey that would take the young woman from privilege to danger.

Belle knew the power she could gain over men, and she set out to use that power to her full advantage. She would win their trust and appear to be friendly to accomplish her ultimate goal. It was this skill that allowed the beauty to silently infiltrate the Union army unit that had marched into Jefferson City. With a bat of an eye and a coy smile, Belle was escorted by the boys in blue to DeBar's Opera House, where she was able to get the soldiers to drink, therefore divulging the secrets entrusted them.

By chatting up the soldiers as they danced at the many social events held in the area, the charmer was able to innocently question her prey without them being aware. The information gleaned from these conversations was then relayed to the Confederate generals, and it proved to be crucial to the limited success of the Confederate army against the Union at that time.

The Union, suspicious of the raven-haired, brown-eyed beauty's activities, set a trap, and Belle was subsequently caught red-handed in possession of incriminating evidence. However, the December 1862 arrest was not of much concern to Belle, who reportedly boasted of her escapades in court. It had been Belle who informed Confederate general Nathan Forrest of Grant's plans to cut off the food supplies by overtaking the Mobile & Memphis Railway, resulting in a large battle.

In court, the suspected spy described in great detail her exploits and even challenged the court to "shoot her like the other spies." She was counting on chivalry to keep her safe, and lucky for Belle, it did. Found guilty as a Confederate spy, Belle was incarcerated in the Grand Street Rebel Prison in St. Louis, Missouri. However, she remained there for only four months, as the Missouri governor took pity on her, probably due to her family connections as much as anything, and rescinded her sentence. The only condition to her release was that she stay out of Missouri during the course of the Civil War, which she did as part of a prisoner exchange. Nothing is known of Belle's activities during this time.

Belle became a staunch lobbyist for the South after the war, at which time she moved back to Jefferson City. And it was there that a dashingly handsome Kansas City doctor and gambler, Newt Hallett, caught her eye, the couple quickly fell in love and were married in short order. After their move to Texas, Belle became her husband's assistant and learned the basics of frontier medicine and faro, both of which she quickly absorbed. These skills would serve her well later in life.

Dr. Hallett and his lovely wife could be found quite often in Metamoros, Mexico, having a good run at the gambling tables. Newt was good for Belle, and she was content to be the doctor's wife, assisting him with his work.

The 1869 yellow fever epidemic took Dr. Hallett's life in Houston and left Mrs. Hallett to fend for herself in the Lone Star State. But this was just one of several tragedies that would scar her life. Within a few months of her husband's death, Belle tried to follow the straight and narrow path by working as a tutor for the Sioux tribe at the Red Cloud Agency. But when that did not bring in enough money to sustain her, she left for New Orleans, where she would soon become a celebrated monte dealer.

Determined to find something more, Belle had heard of the great gold strikes in the Northwest Territory and, ever the adventuress, set off to claim her share—only this time she reinvented herself and would be known as the mysterious Madame Vestal. Madame Vestal presided over faro tables in Wichita, Kansas; Cheyenne, Wyoming; and the streets of Denver, Colorado, with great success, making her a rich woman. Although people, especially men, were drawn to her exceptional beauty, Belle would sit silently and without expression as she dealt her cards or spun the roulette wheel.

But the joy had been begun to drain from Belle's life. While most people would not have admitted this fact, Belle seemed to take pleasure in boasting that she "had never done a kind act, returned a dollar, or asked a favor since I had become a gambler. My luck was invariable; I had a superstition that if I allowed the first thought of kindness to enter my soul, it would break the spell. I hated every man who came to play against me; they came to break my bank, why should I spare them? My husband never gave back money or spared either friend or foe in any play—why should I?"

Belle was known to drink outside the gambling hall but always remained sober on the inside. It was widely known that she despised women and refused to speak to or with them. She did not engage in any silliness such as catfights, and her .45-caliber revolver was her constant companion, sitting silently on the table next to her cards as a warning to anyone who dared to challenge her. It was known that Belle was a good shot and was not afraid to use her weapon.

As the character of Madame Vestal took over, Belle developed what would be her signature look: a red or black velvet dress and ample amounts of diamond and ruby jewelry. She was a sight to behold, and this served her well.

In 1876, when news of the massive gold strikes in the Black Hills of South Dakota came to the gambling hall on Denver's Blake Street, Belle felt that Madame Vestal needed to disappear and that a new identity needed to make an appearance. Thus the exotic Lurlene Monte Verde was born, named in honor of the game she had mastered.

Belle chartered a horse-drawn omnibus for her journey to Deadwood. The wagon train was complete with a bed, cookstove, curtains, bookshelves and all the luxury a social queen would demand, including a maid and sporting men as her attendants. It also served as a traveling gambling den, as furniture and tents were included for the long trek. Imagine the spectacle witnessed by the gold miners as Monte Verde made her entrance into the mountainous town with no less grandeur than Cleopatra herself. It took no

time for the gambling hall to be opened on the streets of Deadwood, and a long line formed to catch a glimpse of the gambling queen who had just graced the sad town. Monte was known to have played and won a few hands against men such as Wild Bill Hickok, Butch Cassidy, the Sundance Kid and John Wesley Hardin.

Soon, the mysterious woman, sullen almost to the point of rudeness, was struck with Cupid's arrow when a handsome gambler crossed her threshold. It was said that Belle experienced love at first sight when she laid eyes on Archie McLaughlin, whose real name was Archie Cummings and who all but ignored the star-struck woman. Cummings would lose at Monte's table every night but would return the following day with a fresh stack of cash. Monte did not care where the money came from as long as he kept coming back to her table.

Eventually, Archie began to show interest. The fact that he was a former guerrilla for the ruthless, bloodthirsty William Quantrill in Kansas did not faze Belle, who was too smitten to care of his former exploits. In fact, she was most likely proud of him for his service to the South. Her new lover was a highwayman who terrorized the stage lines in the Black Hills. But again, this did not matter; in fact, Belle actively participated in the planning of every heist carried out by Archie's gang. She laughed about how callous men—detectives, in particular—were around women whom they did not think were listening to their drunken conversations. Belle played a vital role in keeping the gang informed of the authorities' plans. The *Deadwood Daily Pioneer* would report on April 11, 1924, that "no robbery was undertaken of which she disapproved, and none failed in which she advised and planned the details."

Unfortunately, Belle once again fell victim to a trap when she let her guard down and relayed false information about a gold train to Archie and his gang. Ambushed by the road detectives, Archie and another gang member were wounded in the fracas but escaped. Hearing of this, Belle immediately left her hall and went to Archie's side. Her medical knowledge allowed her to save both men. However, the other gang members were not so pleased with Belle and had to be dissuaded from killing her since she knew the location of their hideout. But Archie came to her rescue, and Belle fell deeper in love.

Boone May, a young road detective ready to make a name for himself, became close with Monte Verde. He knew she was the key to finding the outlaws, and he used his cunning to extract the necessary information out of the gambling woman. This relationship would prove to be the catalyst to Belle's eventual downfall.

Said to be "intimidated by no one but himself," Boone, chief of the Black Hills Stage Line detectives, was himself skirting the fringe of the law as he did whatever he thought necessary to accomplish his job—no matter how unscrupulous. Able to extract bits of information from Belle, Boone and his agents met Archie Cummings along with two other gang members at a train bound for San Francisco. The men were arrested and transported to Cheyenne, Wyoming, for arraignment. While en route, they were overtaken by at least thirty men, who proceeded to lynch the prisoners.

One by one, the men died by the same rope, but when Archie's turn came about, he pleaded for the opportunity to write a goodbye letter to his mother, a request that was instantly denied. Instead, he was given an ultimatum: if he divulged the exact locations of his and Monte's hidden caches, he would be set free. Archie agreed. As soon as his task was complete, however, he learned of the detectives' betrayal—Archie Cummings was immediately hanged. A note placed on his swinging corpse served as a warning for other highwaymen and thieves who might pass by the gruesome scene.

Archie had told the truth, and the couple's strongbox was found and confiscated by the ruthless detectives. A heartbroken Monte Verde was told the awful story by none other than one of the actual vigilantes, who enjoyed her pain. This tragedy would be one from which Belle would never recover. She felt that life was not worth living without her man, so she attempted suicide by drinking poison. Found in the nick of time by acquaintances, Belle recovered in body but never in heart or mind.

There was not enough alcohol to dull or soothe Belle's tortured mind. Guilt riddled her; she simply went through the motions of life as she tried to pull herself together. The Deadwood newspaper wrote that she "lost all of her characteristic courage and surrendered herself to drink."

In March 1878, Monte, Eugene Holman and Sam McHugh were in a rented house behind the Bella Union Theater in Deadwood during a particularly heavy snowstorm. A snowbank dislodged from atop the hill, crashing into the small house and taking it twenty-five to thirty feet downhill before finally stopping. Luckily, no one was hurt in the incident, but this was the last straw for Monte. Lost and broken, Belle left Deadwood and eventually wound up in Leadville, Colorado, in 1879 as the owner of the largest dance and music hall located on State Street. Not satisfied, she continued on, eventually landing in the "wildest of the Wild West" towns: Las Vegas, New Mexico.

Las Vegas was a hotbed of outlaw activity—a place where Billy the Kid, Dave Rudabaugh, Doc Holliday, Big-Nose Kate, Hoodoo Brown and

A modern photograph of what used to be Centre Street, where Belle Siddons worked at the Toe Jam Saloon. The thoroughfare is now called Lincoln Street, so named in honor of the president. *Author's collection.*

Jesse James, among others, had been known to haunt the local saloons and gambling halls. It was also where forty-year-old Monte Verde once again took up her trade at the Toe Jam Saloon on Centre Street. Monte fit right in with the group of ruffians that ruled the town because, by this time in her life, she was fighting a huge addiction to drugs and alcohol, as her broken heart had followed her to New Mexico as well.

While in Las Vegas, Monte worked in partnership with Eugene Holman, who was described as her "heavy man." The *Las Vegas Optic* referred to her as Monte Holman on several occasions and surprisingly dubbed her as a

mother in a blurb tragically stating that "…a man ravished Monte Holman's little girl." An 1880 census shows the couple married and Monte as the mother of a three-year-old girl named Cora. No additional information could be found after this date.

At this point in her life, despite her many years battling addiction to alcohol and drugs, Monte was still considered pretty. She became a vaudeville entertainer at the Globe Theater on the east side of Las Vegas.

Monte's next port of call was El Paso, Texas, where she stayed for about a year before returning to Las Vegas in March 1880 and opening a brothel on Sixth Street named The Parlor. She was welcomed back as a vaudeville actress and delighted people with her banjo playing.

From time to time, the *Las Vegas Optic* would publish poetry received from Monte. Following is a verse that was published in the May 12, 1880 edition of the paper:

> *Alas, my childhood and my blossoms faded,*
> *And I in stranger lands have wandered far.*
> *My buoyance is gone; I'm worn and jaded,*
> *And blighting sorrow came my joy to mar.*

Still in possession of great persuasive skills, Monte convinced a wealthy Las Vegas citizen to build a theater for her so that she could perform anytime she wished. Successful in her bid, Monte finally had her own theater. But as with everything else in her life, this would also end in tragedy, as a fire destroyed the theater in September 1880.

The final chapter in Belle's amazing life played out in San Francisco. After leaving New Mexico, she went back to Colorado and then on to Tombstone, Arizona, on her way to the coast. Temptations of the bottle and the opium dens were too much for Belle to resist. Arrested for open intoxication on a San Franciscan street, Belle was nearly unrecognizable as the beautiful monte dealer who had lived such an unbelievable life. When found, she was placed in a jail cell, and it was not until she approached the bars that a deputy recognized her as Monte Verde. Clothes torn and dirty from her resistance to her arrest, hair straight and covering her face like a veil, the jailer described Monte as "a pitiable object, a complete picture of abject misery and despair."

This would be the last description of Belle Siddons, as she would soon be found dead from an overdose in a San Francisco opium den—a victim of her lifestyle, the tragedy she experienced during most of her life and

the overwhelming need to attempt to dull the immense pain she must have carried with her every day. This woman of such promise and social grace now rests in an unknown grave.

Chapter 8

Doña Tules:
Queen of Sin

A Spanish beauty who worked hard to accomplish her dreams of riches would eventually become the talk of not only Santa Fe, New Mexico, but also the world. Her name was Maria Gertrudis de Barceló, later to be known as Doña Tules or Madam T. Santa Fe, the City of Holy Faith or, as it is known today, the City Different, has always attracted a diverse array of characters within its confines. If Maria were to walk the streets of her beloved Santa Fe today, she most likely would blend in perfectly with the eclectic concoction of people who window shop along the portals and would most likely recognize many of the buildings still standing. Her *sala* in Burro Alley now plays host to a French bistro, but the quaintness that is Santa Fe is still there, the narrow side street guarded by a sculpture of a forlorn burro bearing wood.

As a child, helping her mother complete her duties as a cook for the Salazar hacienda in Taos, Maria dreamed of having the most expensive home in Santa Fe. Her mother's head would shake as the starry-eyed girl announced her plans on an almost daily basis. What Maria considered poverty did not sit well with her, and she learned early on how to capitalize on the affects her striking beauty had on the male species.

Depending on which book you read, there are several different accounts of Maria's childhood. One tells of a young immigrant girl whose family toiled hard for all they had, while another tells that the Barcelós were an affluent Mexican family who did not want for anything. The truth is debated widely, but one thing is certain: the young woman who came from that family knew

A circa 1882 bird's-eye rendering of Santa Fe drawn by prolific map artist Henry Wellge. *Author's collection.*

the power of money and used her intelligence and looks to accomplish more than any Hispanic woman of her time in the New Mexico Territory.

Not much is written about Maria's early years, but it is known that after Mexico gained independence from Spain in 1821, she and her family moved to the Territory of New Mexico and settled in the tiny village of Tomé. As girls were not allowed to attend school at the time, Maria was educated by her older brother Trinidad. It is said that she was able to sign her name with great flourish at a time when most of her compatriots were able to place only a simple "x" as their signatures.

On June 23, 1823, a twenty-three-year-old Maria married Manuel Antonio Sisneros of Tomé. The Catholic priest who officiated the ceremony

gave Maria the title of Doña, which is given only to women of high social standing and quality. This was surprising to the townspeople because not only was she at least four years older than her groom, but she was also four months pregnant at the time of the wedding—both scandalous events.

Maria was to have two children with Sisneros, but tragedy would strike each time, as neither child would live through infancy. Her first son, Jose Pedro Sisneros, was to live for only one month after his birth in October 1823, and her second son, Miguel Antonio Sisneros, would succumb to death four months after his birth in 1825. In 1826, an abandoned child, Maria del Refugio, became the adopted daughter of Maria and her husband. The girl was to live with them until 1841, when the fifteen-year-old married a Mexican trader. The adoption apparently satisfied the maternal needs of Maria, who began to concentrate on her gambling career. She would receive her first gambling fine at Real del Oro in 1826.

While still a young woman, Maria secretly caught the eye of Don Manual Armijo, the governor of the New Mexico Territory and also a married man at the time. But this small fact did not matter much to Maria, as she was also married. Armijo, the last governor of New Mexico under Mexican rule, would pass away one year after Maria in 1853 and be buried at San Miguel Catholic Church in Socorro.

Judged harshly by the standards of the nineteenth-century American men who frequented her place of business, Doña Tules was portrayed as a fallen woman with no discernible redeeming qualities. In truth, she was a pleasant-looking, lively woman with long, bright red hair and flashing eyes who could—and did—charm everyone she encountered. These attributes intimidated the American males of her time.

While dealing monte, Doña was dressed to dazzle, often wearing velvet and lace dresses accentuated by necklaces of diamonds, rubies and a signature heavy gold cross. Legend has it that Doña would use one of her servants as a human footstool so that she would not dirty her brocade slippers.

Varying descriptions of Doña's looks can be found. In some accounts, she is described as a strikingly beautiful woman, while one 1846 account states that she was an "old woman with false hair and teeth." A *Harper's Bazaar* article written in April 1854 also gave a very unflattering glimpse of the respected lady.

This woman, who owned the most popular gambling hall and saloon in Santa Fe, was a fashion icon of her day and was highly respected in the community. She exuded charm and wit while surrounding herself and her patrons with extreme luxury. To enter Doña Tules's house, one had to

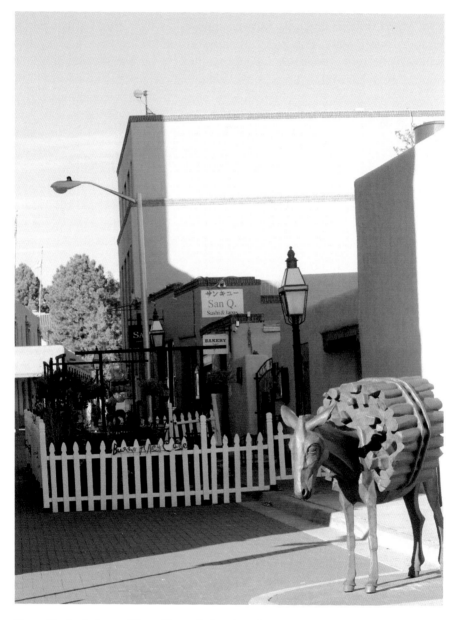

Burro Alley in the heart of Santa Fe was the location of Doña Tules's *sala*. *Author's collection.*

carry an invitation. She did not let just anyone into her lair. Sometimes her invitations were more personal, with only a bow of the head or a knowing glance to a gentleman who caught her fancy.

At the end of Calle de la Murella (the Way of the Walls Street) in the Torreón District, Lady Tules's *sala*, or gambling hall, was a large room in which she entertained her guests. The *sala* was plenty large enough for the dances and soirées that were held frequently, as well as the gambling activities. This large adobe building took up the entire block on Burro Alley, between San Francisco and Palace Streets.

Decorated in the highest of taste, Doña Tules's *sala* was furnished with fine Brussels carpet, crystal chandeliers, hand-carved card tables and ornate mirrors. It is said she had one clock in the house whose hands were continually on twelve and six. When asked why the clock was not running, she coyly said, with a twinkle in her eye, "I only wind the clock on the holidays; I do not want to grow old too quickly."

Foldable mattresses covered in fine Mexican blankets would serve as couches on which the guests could lounge. These were whispered to have been utilized in other capacities by the end of the evening. Doña was known to have a number of "nieces" from Mexico who would visit constantly, and she was rumored to run a house of pleasure as well as a saloon. This fact earned her the nickname "Queen of Sin."

A young army wife, Susan Magoffin, who traveled to the wilds of the New Mexico Territory and kept journals preserving her thoughts along the way, also described Tules as a woman who "made her living by running a house where open gambling, drinking and smoking were enjoyed by all…with no thought of being socially degraded." In young America, during a time in which women were thought of and treated like possessions, the rights of the New Mexican women were a complete oddity. Knowing more freedom than any culture surrounding them, these women were allowed to own property, will this property to their daughters (not just their sons) and actually have a say in court.

Traveling to all of the outlying camps situated around Santa Fe, Doña would acquire a reputation with the men, who would flock to her *sala* on Burro Alley or one of the numerous other houses she owned around town to play faro. One of her houses was located on the present-day site of the Santa Fe County Courthouse.

Affluent Tules would give loans to people she knew to start up mines or just to live, but public opinion turned against her when she began to take the recipients to court if they were unable to repay her. Always reinventing herself, Tules was to garner a more generous reputation as she donated to the Catholic Church and was known to support poor families.

In a strange twist, Doña's husband mysteriously disappeared in 1841 after the marriage of their adopted daughter. Not one to waste time, Doña quickly took up with several lovers.

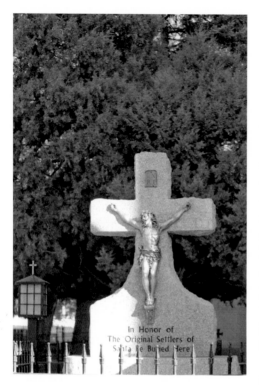

A monument honoring Doña Tules and other pioneers who were buried on the grounds of the St. Francis Cathedral in Santa Fe. *Author's collection.*

The cash flow was not just to the community, as Doña would also pay more than her share of taxes to help out the New Mexican government during hard times, as well as lend money to the U.S. Army after its invasion of New Mexico in 1846 so that it could pay the troops' wages during times of shortfalls. Because of this relationship with the military, Doña was able to hear drunken plans in her gambling halls and relay them to the proper authorities. She is given credit for preventing a possible massacre when she overheard conspiracy plans being laid out during a game of cards.

Doña was to become a U.S. citizen through the Treaty of Guadalupe Hidalgo, which automatically legalized Mexican citizens in the territory in 1849.

After her death on January 17, 1852, Doña a left a reported fortune of over $10,000 and several houses to her family, as well as a considerable donation to the Catholic Church so that she could be buried at La Parroquia Church, which is now the site of the Saint Francis Cathedral. Her grave site has been lost to history, but she is believed to be one of the last people to be interred within the church's walls.

The extravagant funeral was highly attended and presided over by Bishop Jean Baptist Lamy, who was made famous by New Mexico author Willa Cather in *Death Comes for the Archbishop.*

Belle La Marr: Madam Varnish

The boom in gold and silver in White Oaks, New Mexico, attracted many miners who dreamed of gaining riches in the newly opened mines. Many accomplished their goals, and the small town grew literally overnight. Gold fever hit the small tent community hard as word spread of the discovery and sheer amount of gold and silver in the mountains surrounding White Oaks. First to arrive were the miners (or men who had recently become miners), most of whom were hardworking but blinded by the thought of possible riches.

Originally from Missouri, Miss Belle La Marr arrived in town on a stagecoach by way of Las Vegas. Accompanied by her three "daughters" and claiming to be a widow, she made her official entrance into White Oaks society with a flourish. Together, the four women set out to lighten the heavy load of the miners' pockets by enticing them into a game or two of monte or faro.

Burlesque entertainment had been Belle's game in St. Louis, and it was there that she learned her trades. As a madam to twenty or thirty girls in St. Louis, Belle grew tired, but word of the new boomtown had piqued her interest, and she decided to head west. In all probability, Belle La Marr was not her true name. It is more likely that the entertainer "borrowed" the moniker from a popular play of the same name.

White Oaks, an exceptionally wild place, attracted to its streets the likes of Billy the Kid, "Arkansas" Dave Rudabaugh and Billy Wilson. Billy the Kid felt very at home in the little mining town, thinking of it as his own personal

Gold fever hit New Mexico before it did California. Mountains surrounding the boomtown of White Oaks provided nearly $40 million worth of the precious metal. *Library of Congress.*

resort. No doubt Billy and Belle had dealings with and mutual respect for each other as thieves. Billy was making a good living "trading horses" from ranch to ranch, while Belle was making a killing off the hard work of the miners she charmed with a flirty smile.

Belle, who was described as a striking beauty with creamy skin, blue eyes and dark hair, first worked at the Star Saloon dealing faro and poker. This is also where she earned her illustrious nickname, "Madam Varnish," as she was said to have been as "slick as varnish."

Not satisfied working for others, Belle desperately wanted to run her own business. To accomplish this goal, she set her greedy sights on an unsuspecting Chaves County treasurer who had played at her tables and, probably during

a tipsy episode, let her know his profession and that he was in possession of a large amount of the county's money.

In what had to be whirlwind courtship, the treasurer soon found himself married to the card shark in Roswell but only after he promised he would take care of his new bride and her "family." So, with the girls along for the honeymoon, the couple started their married life together.

It surprised the citizens of White Oaks when the newlywed Belle and her entourage returned to the gambling hamlet without her groom. Also surprised was the groom, who awoke to discover his new bride missing, as well as the $3,500 of Chaves County money he had stashed under his pillow. The groom immediately summoned the law and had Madam Varnish arrested. Proving that her slick ways were not limited to the saloon, Belle was soon released on her own good word after sweet-talking the judge.

Incensed that her groom would have her arrested, Belle and her girls returned to Roswell to have a word with the man, and it was not long before the tables had been turned on the treasurer. Belle threatened to accuse him of absconding with the county's money if he pressed charges against her. It is not known why he had that amount of cash with him at the time of the marriage or why he would keep it under his pillow instead of in the bank.

The adobe ruins of Madam Varnish's Little Casino in the White Oaks are barely visible today. *Author's collection.*

Madam Varnish was never tried for the theft, but amazingly enough, she was able to open her own place shortly after returning to White Oaks. Dubbed the Little Casino, it would soon become known as the best saloon in the Hogtown subdivision. Hogtown was home to the seediest of the town's characters, a place where the constant clack, clack of the roulette wheel and the lusty laughter from the demimondes could be heard deep into the night.

It was through the Little Casino, where she offered whiskey, women and gambling, that Madam Varnish became the richest woman in the tiny town known as the "liveliest town in the New Mexico Territory." Belle played host to outlaws, lawmen, cattlemen and travelers alike—as long as they had money, they were welcome.

But Madam Varnish was not the only slick person to call White Oaks home. At the Star Saloon, across the street from the Little Casino, they sold three grades of whiskey: good, better and best. Each grade was priced accordingly, leading the drinker to think that he was getting a superior grade of whiskey if he spent more money. But as was soon discovered, this was not the case; a curious patron came to realize that all three grades of whiskey were being siphoned out of the same barrel.

Another story serves as a true example of necessity being the mother of invention. According to the *Las Vegas Optic*, "a churchgoing merchant came up with a new way to sell liquor from his general store. He cut a door in the side of his store and built a small shed on the adjoining lot. A patron would enter the shed from the store, take a cup hanging on the wall and tap his drink from the whiskey barrel. After placing his ten cents on top of the keg and finishing his drink, he would walk back into the store."

Unfortunately, once all the gold had been mined out of the mountains and the railroad bypassed White Oaks, the town saw a steady downturn that nearly led to its demise. Today, White Oaks residents keep the spirit of the Old West town alive, and Madame Varnish would likely get a chuckle if she were to walk amongst the characters who frequent the modern-day No Scum Allowed Saloon.

PART III:
SOILED DOVES

Lizzie McGrath:
The Lilly of Copper Avenue and
the Shady Ladies of Albuquerque

Mary Elizabeth "Lizzie" McGrath was born the daughter of an Irish immigrant carpenter and Civil War veteran in Bloomington, Indiana. Legend has an innocent twenty-one-year-old Lizzie arriving in Albuquerque, New Mexico, in 1882 on the arm of a railroad executive who then promptly abandoned her. However, there is evidence that she had already been plying her trade in Topeka, Kansas, and that the gentleman was simply a means by which she could get out of town. Regardless of the circumstances, she was abandoned in Albuquerque, but being a smart, enterprising woman, she immediately saw an opportunity and grasped it without hesitation.

Family history has Lizzie being much younger—closer to fourteen years of age, in fact—when she left Kansas. This would make sense because the census records indicate another daughter, Mae, being born into the family around 1875. The infant is believed to be Lizzie's daughter. There is speculation that a carpenter who lived with the family for many years was the father of the child, and this also may have been the reason for Lizzie's departure to New Mexico.

Lizzie's career in Albuquerque began at Gertie Oliver's Wine Room, where she worked with several other young women. It did not take long before Lizzie set the goal of owning her own house. The railroad continued to bring customers to the red-light district of the newly formed town, making Gold, Silver, Copper and Railroad Avenues the places to be for a man looking for some company. In fact, the railroad was the reason the red-light district was so named. Generally, a trainman would carry a lantern with

Lizzie McGrath of Topeka, Kansas, would become one of the richest women in New Mexico. *Courtesy of the Albuquerque Museum, Image #1984.014.001, Cobb Collection.*

a red globe, and when he was visiting the ladies, he would hang the lantern outside on the door. This area of town would often glow bright red, especially on payday.

Not one to rest on her laurels, Lizzie was soon able to buy her own house on Copper Avenue. The house became known as the Vine Cottage and Lizzie as the "Lilly of Copper Avenue." Her reputation in Albuquerque grew, and many dignitaries were known to cross her threshold.

No matter how much she tried, Lizzie was unable to stay out of trouble with the local law enforcement. Although the parlor houses were not legal, they were, in a way, licensed. Every month or so, constables would raid the houses and take the madam and a few girls into custody. After paying a fine, they would be released, only to have the procedure repeated again and again.

Lizzie was not one to let these little annoyances affect her; she was kind to the local law enforcement and was not afraid to use them when she needed them. She would take her clients to court with no qualms if she was owed money. Lizzie was also known to be very generous with her wealth and often contributed to community activities and charities.

Due to a city-imposed ordinance that made it illegal to operate a house of ill repute within seven hundred feet of a church or fraternal organization, Lizzie and two other madams were stopped from opening a second house on Third Street near Saint Paul's Lutheran Church. The city officials thought they had been successful in stopping the establishment of yet another

disorderly house, but they did not know Lizzie McGrath and her cohorts as well as they thought they did. Lizzie proceeded to make the church an offer of $3,000 if it would move the congregation and sell the building to the ladies. The church happily accepted the offer, and the building was then razed by the women, much to the dismay of the protesting neighbors.

Another incident involving this ordinance would land Lizzie in trouble with the law in 1911, when she opened a house within the legal limit of a Masonic lodge. Lizzie would take this case all the way to the New Mexico Territorial Supreme Court, earning her the honor of being the only madam to do so.

The list of witnesses set to testify against McGrath read like a telephone directory. Neighbors and about every prominent man in town bore witness against her, even the ones who were most likely her clients. The transcript of the trial contains many graphic references to the madam's lifestyle and that of her girls. Although McGrath's attorney was extremely competent and made good points in refuting the testimonies, Lizzie lost the case.

Minnie Carroll and Lizzie McGrath were the only two madams in business between 1910 and 1914. The City of Albuquerque officially shut down the red-light district in 1914 after many years of struggle and constant work by the "good" women of the city. After the closure, Lizzie took an extended vacation to South America before returning to the States and visiting Washington State. In 1918, fifty-eight-year-old Lizzie would continue her world travels as she set out on a long tour of China, Japan and India. Minnie

Lizzie, shown here with a woman some believe to be her daughter, Mae, took full advantage of her wealth and traveled frequently. *Courtesy of the Albuquerque Museum, Image #2000.017.001, Cobb Collection.*

Carroll, who had converted her house into a legitimate boardinghouse, got married and eventually moved to California.

It is not known how many times Lizzie saw her family, but after her death in 1922, her worldly goods were shipped to Topeka, Kansas, where they remained in a barn until 1960, after the death of Mae, whom some believe was her daughter. When the trunks were opened, a treasure-trove appeared. Silver coins, rubies, emeralds, sapphires and pearls filled the chests, along with first-edition books and a silver hairbrush set, among other items. An auction was held, and now homes all over Kansas contain bits and pieces of an amazing life lived by an equally amazing woman.

THE SHADY LADIES OF ALBUQUERQUE

The railroad was the savior of many a town in the Old West, and the fledging town of Albuquerque was no exception. Before the trains connected the towns of the New Mexico Territory, transportation and shipping took weeks to accomplish within the state borders. The railroad cut these times drastically, allowing further development of the territory.

The railroad meant jobs and workers—a boom for the girls who worked along Railroad Avenue, now Center Avenue. *Library of Congress.*

Old Town Albuquerque, the site of the "red-light district," was seen as a bruise on the city's reputation, but the district would flourish for many years. *Library of Congress.*

With the trains and the tracks came the men who worked on them, and these men brought with them prosperity. There were three divisions in Albuquerque's red-light district, the highest being the Parlor House, which featured refined, attractive women whom the madams dressed in the latest fashions. Some of the names most widely associated with the glory days of Albuquerque's red-light district read like a who's who of strong, prosperous women—Minnie and Stella Carroll, Victoria Kirk and Gertie Oliver are just some of the madams who owned houses in the district.

Madam Henry, notorious for her crazy antics, would often get drunk and raise Cain on the local streetcars in Albuquerque. On other occasions, Madam Henry would go to the upscale saloons and do an Old West version

of karaoke with a voice that was described as "screechy." One night, she raised the interest of two men with her singing, each with his own opinion of the performance. The men got into a heated argument about the singer, and the owner demanded that Madam Henry and her defender leave the saloon. In the short time it took to go to Madam Henry's house, she had changed her mind and pulled a revolver on him. Startled, the man disarmed the madam by throwing the weapon into the street, where it immediately discharged. No one was injured in the incident, but it created quite a stir in the neighborhood.

A lady known as Madam Maggie owned the largest bordello in Albuquerque in 1882, while Rumalda Griego operated the most notorious bagnio. This was a two- or three-room house in the Old Town area of Albuquerque located right down the street from Lizzie McGrath's Vine Cottage. The house had up to three beds per room, with ladies often entertaining simultaneously in the same room.

Early Duke City madam Nora Moore was a victim of a random dynamiter. An unknown person who had been blowing up sections of sidewalks in the red-light district graduated to attempting to blow up Nora's house. A one-foot hole was opened up on the roof of the house, but luckily no one was hurt.

One of the most frightening legends of the Albuquerque red-light district is that of Haunted Hill. Located on the northeast end of Menaul Boulevard, locals say the area is ridden with the pitiful ghosts of the crib women who had been lured up to the area by an old man living in one of the caves at the top of the hill. The man made promises to get the women to leave their posts in town and then murdered them once they entered the cave. Lantern lights, footsteps, sounds of bodies being dragged and bloodcurdling screams have been reported by residents who live near the hill. The crimes were never investigated because the women were considered expendable, and the town was glad to be rid of them.

Madam Millie and the Tarnished Women of Silver City

The story of Mildred Cusey, forever known as Madam Millie, of Silver City, New Mexico, is one of tragedy, fierce family bonds and pure heartbreak.

Mildred, who was born Willette Angela Fantetti but would call herself Millie, and her older sister, Florence, were orphaned at a tender age. Nearly five million people died during the 1918 Spanish influenza epidemic, including Millie's Italian immigrant parents, who had settled in Paducah, Kentucky, to raise their family. Millie, only nine at the time, and Florence were placed in what proved to be awful foster homes.

To escape the harsh treatment, the girls ran away to Kansas City, where Millie went to work plucking feathers from chickens. The sisters took up residence in an abandoned tenement and were constantly bullied by the local thugs. When the authorities took notice, the girls were removed from the tenement and placed into new foster homes. Millie was placed with the family of a police officer who reportedly mistreated and starved her. It was then that Millie was first exposed to prostitutes, as she ran errands for them to make extra money—no doubt to help with another escape.

The sisters were reunited when Millie was eventually sent to live with Florence at her new foster home. Florence contracted an aggressive form of tuberculosis and was then sent to a Catholic home in Deming, New Mexico. It was now up to Millie to make a life for them while attempting to provide expensive medicines and treatments for her ailing sister.

Starting out as a Harvey Girl, Millie soon learned that the travelers were interested in more than just the food on the menu, and she set out to relieve

Art Deco storefronts grace the streets of Silver City. The Hudson Street home of Madam Millie, the hostess of Silver City, was the hub of social activity. *Author's collection.*

many of them of the extra cash in their pockets. An industrious girl, Millie, who had lied about her age to get the Harvey Girl position (one had to be eighteen years of age, and Millie was only fourteen when she started), soon found that her side job was far more lucrative than being a waitress.

An extremely unfortunate occurrence involving a brutal rape and life-threatening beating surely would have deterred most from continuing such a dangerous lifestyle, but not Millie—she was on a mission to save her sister.

While in Silver City, Millie began working at a brothel and was discovered by the town marshal, who ousted her for being underage. Infuriated, Millie told him, "I will come back, buy the whole block and run it to suit myself." And this is exactly what she did by purchasing three houses on the 500 block of Hudson Street and establishing the 500 Club.

When Millie opened her house of ill repute (which was locally referred to as the "pest house") in Deming, New Mexico, in the late 1930s, she left in charge the madam who had already been working there. She would go to Deming every night to check receipts and was an extremely active businesswoman. She was also involved in many charities and was even responsible for putting several children through college.

Millie soon began crossing the border into Mexico and singing in the cantinas there. This is also where she met the lady who would start her on the way to becoming the legend she is today. This lady would encourage Millie to travel to Carrizozo, New Mexico, to meet with Madam Billie, who ran a brothel in the middle of the desert.

The tenacity of the young woman was to sustain her through many years servicing the men of New Mexico. The girls worked hard in Millie's house; she was not a slacker and expected the same from her "little cats," as she called them. One of the first duties of a new "little cat" was to walk Millie's poodle, Lula. Lula would be adorned with a hat affectionately named the "whoring hat" because it was a clear indicator that the girl walking Lula was new to the house and advertising the goods.

Much was expected of the girls who worked for Millie, who was quoted as saying, "I wasn't running a finishing school for whores. If they didn't want to make money, I didn't want them around." The girls were not allowed to go to bars on their own or with clients; they were to remain in the house and rely on Millie for their existence. Alcohol and drugs were not tolerated in the house, and frequent medical examinations were performed on the girls to make sure they were all healthy. The only time Millie encouraged her girls to go to town was to buy clothes. She believed in buying from the community, therefore stimulating the economy.

The average amount of trick traffic for Millie's house ran about seventy per girl each night. On one particular night, an enterprising young woman named Birdie, trying to impress her boss, donned a pair of new shoes and turned a staggering ninety-three tricks in one evening. When asked if she was tired, the girl simply replied, "No, but my feet hurt something fierce."

While still in her twenties, Millie was running six houses—five local to Silver City and the surrounding area and one in Laramie, Wyoming. During her career, she came to own not only brothels but also beauty parlors, bars, taxi stands, restaurants, a ranch and a parking lot. People across the nation became so enthralled with Madam Millie that she was featured in a 1954 issue of *Good Housekeeping* magazine.

In 1978, Millie held an auction of all her memorabilia from her bordello days and cleared out a warehouse full of memories.

Millie would be married at least three times during her lifetime. Her first husband was Howard Shapiro, a wealthy, unassuming man who ignored the young girl most of the time and would die from tuberculosis five days after Florence in 1936. Her second husband was Ben Hacker, an abusive drunk who reportedly once beat Millie with four dead chickens in a drunken rage. The couple had a volatile relationship that, throughout the years, would result in a broken arm, a broken nose, a fractured jaw and an eye knocked out of the socket for Millie. In addition to paying for expensive plastic and reconstructive surgery, Millie also had to pay Hacker $50,000 in the divorce. Millie's third husband was James Wendell Cusey, a construction excavator and a World War II navy veteran. Their life together was peaceful, and Millie would write a sweet memorial to her husband of thirty-plus years when he passed away on February 20, 1991: "I look across at his chair where he once laid his head and think of all the happy days that we shared together. But now his chair is empty, and those happy days are gone. But we will share more happy days in the Great Beyond. Always in my heart, your loving wife, Mildred." Mildred would join Wendell on November 8, 1993, laid to rest beside him in the Fort Bayard National Cemetery.

THE TARNISHED LADIES OF SILVER CITY

In the late 1800s, the streets of Silver City were as wild as wild could get. Outlaws, miners and prostitutes intermingled with the rest of the population to create an eclectic mix. The notorious William H. Bonney, aka Billy the

Kid, who lived in Silver City in his younger years, described the city as "a town with all its hair on, its population a mixture of the most fearless and the most desperate men on the frontier."

Silver City saw a huge boom in population when gold, silver and copper metals were discovered in the surrounding countryside, and the fortunes of men were made and lost in one day. The men were not alone in pursuing the riches. The spirited ladies of the burgeoning town were more than happy to lighten the monetary burden of the miners, who were stricken with heavy pockets.

Prostitution did not make a name for itself in Silver City until about 1884. The denizens of the street had their own language and knew how to work the newspapers to get their message out. Clever ads stating that a certain girl was "registered at Hudson's" meant that there was a new girl in town. The newest arrivals were Verdie Bell and Ollie Barbee, both of whom knew trouble well. Within three months of their arrival, they were arrested for soliciting aid for the hospital—not an awful act, except for the fact that they had dressed as Sisters of Charity nuns to get these funds.

However, the two most recognizable names of Silver City's tarnished ladies are Kate Stewart and Bessie Harper. Born in New York, Kate came to Silver City and set up her first house of ill repute on Texas Street. Rumors of Kate's wealth circulated, igniting local curiosity about the newcomer. Rumors also flew about the romantic relationship between Kate and gambler Jim Thurmond. Jim was the brother of Frank Thurmond, who was the husband of Carlotta Tompkins, otherwise known as the notorious Lottie Deno.

Kate's association with Jim may have been the catalyst to a series of incidents in which an unknown person attempted to destroy Kate's house by blowing up her porch with dynamite. Although usually not complimentary toward the girls, the *Silver City Enterprise* did come to Kate's defense in this incidence: "No matter how aggravated the cause, such acts amount to willful murder, and a necktie reception should be immediately tendered the perpetrators of such fiendish crimes as soon as their arrest and conviction can be secured."

Despite her faults, Kate gave back to her community and was generous when the hat was passed, especially to nearby Fort Bayard when it needed a new wagon road. This generosity, of course, would eventually benefit Kate, as the soldiers used this new road to get to her door, making her ten-dollar donation grow tenfold.

Other names connected with the Silver City red-light district include Lucy Coronne, Claudie Lewis, Gracie Nash, Edna La Ray, "French Nettie" Simon,

Ruby Fowler, Large Cora, Dona McNeil, Riola Mescarte, Edna Lynn, Ray Rich and Big Jess. It was never a dull moment for Sheriff Harvey Whitehill, who had the difficult job of trying to keep the peace in the raucous town. Throw alcohol and jealousy into the mix, and you get a volatile situation no one would envy.

A popular Silver City legend tells of an angry Bessie Harper taking a sock loaded with a rock to rival Ruby Fowler. Bessie is said to have "knocked her [Ruby] senseless, beating her in a shameful manner, cutting her scalp, and face clear through to the bone in several places," according to the *Enterprise*.

Poor Millie Forest, an unsuspecting bystander, was in the wrong place at the wrong time when her fellow sin sister Edna La Ray tried to kill Lucy Washington with a six-shooter in a fit of jealousy. The bullet missed Lucy but struck Millie in the foot, leaving her in agony and in danger of losing her foot. Millie's career in the district was over in an instant.

Alice Ivers, otherwise known as Poker Annie, was known to have spent a few weeks gambling in Silver City. Her winnings allowed her to move back east to open her own house. Notorious stage robber Pearl Hart was also captured in Deming in an escape attempt. She was returned to Arizona for trial and eventual imprisonment in Yuma for five years.

The assorted ladies of the Silver City streets eventually sought better prospects elsewhere, leaving only a few of the more experienced madams, such as Madam Millie, to rule the roost.

Beulah M'Rose and the Spirited Ladies of Phenix

B eulah M'Rose is the perfect example of what a woman will do to save her child. Born in Texas to a typical pioneer family, Beulah started out life normal and happy. Hard work was the way of life back then, but it kept most people out of trouble and on the straight and narrow path. If you had asked anyone who knew Beulah's family, they would have said that Beulah was destined to become a frontier wife, following in the footsteps of her mother—but they would have been wrong.

Born Helen Eugenia Williams to William Crawford Williams and Annliza Ellison in Berry's Creek, Texas, on November 1, 1872, the blond, blue-eyed beauty became another member of an already large family. As was the custom in her time, she married young—at fifteen—and started a family of her own. Helen was known as someone who liked to have fun, and when she met Steven Jennings, the whirlwind courtship landed her in the middle of nowhere on a ranch. She was not pleased with the situation, and she was lonely since Jennings was frequently absent.

Her marriage to Steven Jennings did not turn out to be a happy one. A pregnancy occurred early on, but sadly the baby girl would not live more than three days. The child's death devastated Helen, who became depressed but forged ahead. The child was laid to rest without a marker under a tree in the couple's front yard. Another child, this one a boy, would also die before reaching infancy, but his death brought a far different reaction from Mr. Jennings. He would receive a headstone and was grieved by both parents.

Polish cowboy Martin M'Rose (right) was described as a good man who never got into any trouble until "he married the prostitute" in Phenix. This union would cost him his life. *Courtesy of nearlovingsbend.net.*

Abuse would work its way into the Jennings household, forcing Helen to flee, taking her daughter, Laura Blanche, with her. Afraid that Jennings would find her, Helen cut the girl's hair and dressed her as a boy, now called Albert. Wandering around Texas, Helen worked jobs along the way. It was thought that during this time, Helen took up the profession of prostitution to support herself.

A Polish cowboy named Martin M'Rose (Morose) had signed on with the Eddy/Bissell Cattle operation in Eddy (now Carlsbad), New Mexico, about the same time Helen had found her way to Phenix. Going by the name Beulah, Helen set out to find a rich man through her work at the Silver King Saloon.

Martin was able to quickly go from cowboy to ranch owner, which caught the eye of Beulah. As with most men in the area, Martin spent a good deal of time in the various saloons in Phenix, fully enjoying the entertainment they provided. As the imminent party girl, Beulah took advantage of Martin's jovial demeanor and latched on to him with both hands. The attraction must have been mutual because the couple was soon married in the Silver King Saloon by owner and sheriff Dave Kemp.

Although described as a man who never got into trouble, Martin was eventually accused of cattle rustling in the Eddy area. After fleeing to Mexico with Beulah to escape the charges, Martin convinced Beulah to return to the United States and get him representation, as he was afraid he would be killed if he came back himself.

In El Paso, Miss Beulah found a new attorney who had just hung his shingle: John Wesley Hardin. The outlaw/gunslinger turned attorney took Martin's case with very little convincing from the pretty woman in his office. Controversy arose when Hardin learned Beulah was in possession of Martin's life savings, which she had been instructed to use to free him from the charges.

A relationship between the two would form, but it would be far from the normal client-attorney type. After a brief time, neither wife nor attorney cared whether Martin made it back to the States. Hardin helped Beulah find uses for the money she was holding by becoming part owner of the Acme Saloon in downtown El Paso and publishing a memoir of his life, which Beulah helped to write.

It is thought that local lawmen formed a plot to extradite Martin from his hiding hole in Mexico by using Beulah and, of course, his money as bait. Lured to the Mexican Central Bridge in El Paso, all of Martin's fears were realized as he was gunned down in an ambush. A bloodstained letter addressed to Beulah was found in his coat pocket. Beulah was good enough to pay for Martin's funeral, at which she and her attorney were the only attendees.

When Hardin left town, Beulah would become bored and wander into the bars to stir up some excitement. On one occasion, when she began to shoot up one of the local saloons, she was arrested by John Selman Jr. (with whom she had been flirting) and spent the night in jail.

Upon his return, Hardin was not happy to find out what had happened to his lady, and he threatened the lawman and his son. Six weeks later, Hardin found himself on the receiving end of John Selman's bullet and was laid to rest three plots away from Martin M'Rose. Beulah, who had left Hardin during this time because he had threatened to kill her, returned and paid the $77.70 bill for Hardin's funeral, most likely with the remainder of Martin's funds.

Distraught, Beulah and her daughter would leave New Mexico for Arizona and, finally, California, where she would pass away in an opium den in a Sacramento alley on September 11, 1904. She died alone and forgotten, as she had relinquished her daughter to a Catholic orphanage. The location of Beulah's grave is said to be under a parking lot at the Sutter Middle School in Sacramento that was originally part of the Sutter Fort Burying Ground.

THE SPIRITED LADIES OF PHENIX

In 1892, two miles south of the newly established town of Eddy (now Carlsbad) in southeastern New Mexico, a new, livelier hamlet was born. Because its sister was dry, Phenix rose up to serve the needs of both communities on April 23.

In the beginning, the founders of Phenix had lofty ideals for their town. An opera house, restaurants, theaters and several saloons were built, all of which were frequently patronized by the citizens of Eddy. Phenix was not just another quickly built cow town full of canvas tents and pot-bellied stoves; it was properly surveyed, platted and christened. Buildings were constructed of wood, with some of the later buildings having more of a

The last structure in Phenix was an adobe brothel. The building met its demise in 1982 when the ruins were torn down. *Author's collection.*

New Mexican flair in adobe, and spanned three blocks. But as Phenix grew, so, too, did its rowdiness.

Unfortunately, Phenix was soon to earn the unenviable title of "one of the West's most vicious sin towns," labeled as such by area newspapers. Unable to find a place to drink and unwind in Eddy, cowboys, travelers, gamblers and, eventually, outlaws found their way to Phenix's saloon doors, some of which were ironically owned by Dave Kemp and Dee Harkey, local Eddy lawmen. Joining Beulah and Martin M'Rose in the new gambler's haven were notorious gunfighters and outlaws John Wesley Hardin, Lon Bass, Jim Miller, "Black Jack" Ketchum and Clay Allison.

Ed Lyell and his wife were the pimps of Phenix, as well as co-owners of the Silver King Saloon. Their partner was Dave Kemp, who was to gain notoriety as the accused killer of Les Dow, his opponent in a local race for Eddy County sheriff. Kemp had been convicted of murder in his youth and sentenced to twenty-five years in a Texas prison, but he had been pardoned by the governor—even after an escape attempt that left him with two broken ankles.

Also attracted to Phenix were the fallen women, who numbered sixteen strong at the peak of the town's existence. One of these women was Goldie Elliott, a brazen beauty and the most popular of the soiled doves who haunted the saloons and brothels in the tiny western town. Due to her constant brushes with the law, Goldie, who could hold her own and was known as a fighter, was described as a "hellcat" by the *Eddy Argus*. One particular incident with a fellow brothel inmate caused a sensation in the prudish Eddy.

It was standing-room only in an Eddy courtroom as Goldie relayed every sordid detail of a catfight with fellow working girl Rosie, who had broken a beer bottle over Goldie's head in a fit of rage and jealousy. Colorful language and descriptions were heard by the court attendees, who drank it up quicker than the whiskey that flowed so readily two miles away. Rosie was fined five dollars and told not to break anymore bottles on anyone's head.

At one point in Phenix, the harlot population had risen to over fifty strong, and the crime rate rose proportionately as well. Havoc was the name of the game in Phenix—nightly gunfights were commonplace, and there were complaints from railroad passengers of rocks being thrown at the windows as their trains passed through town. Other complaints came from family men who had to go through Phenix en route to other small communities in the area as they were frequently accosted by "half-naked women" trying to drum up business.

The prostitute population rose to more than two hundred in the town's heyday. Some of these denizens were Mae Green, Lilly Bassett, Marie Gonzales, Florence Rojas, Alice Davis, Minnie Smith, Midget Crummens and Hattie Tripp. Hattie married Harry Coalson, the manager of the Phenix Theater, in August 1893 (the couple had previously been arrested for being in violation of the Edmunds Act and were charged even after their marriage). Two short months later, Hattie would sustain fatal injuries after falling off a hack at Black River, a popular spot where locals spent time relaxing and fishing.

The life of a soiled dove was hard. Many simply succumbed to the lifestyle after realizing that there was nothing else for them, but others were brought into it unknowingly. Such is the story of fifteen-year-old Theodora Guerrera of Ysleta, Texas, who was brought to El Paso by an old woman who told her that she was to be a housekeeper for a prominent family in Eddy.

Vulnerable in every way, the girl trusted the woman, completely unaware that she was actually being added as one of the new Silver King girls. And because of a fifty-dollar debt that she incurred (or was incurred for her) after receiving clothes and housing, she could not leave. The young girl soon became consumed with disgrace, and she tragically ended her life with a large dose of morphine. Funeral expenses were paid through a collection taken up by the rest of the brothel girls. The location of Theodora's grave is unknown, as are the final resting places of the other fallen girls who passed away while working in Phenix.

One of the longest surviving rumors to come out of Eddy's very own sin city is that of a tunnel that led from the Dark Canyon Draw to the back door of a pleasure house located a few hundred feet away. This tunnel served the fine, upstanding gentlemen of Eddy who wanted to remain anonymous while partaking in the enjoyments of Phenix.

In order to control the brazen activities of the inhabitants of Phenix, Deputy Sheriff Dee Harkey was elected to clean up the hamlet and lessen the amount of cohabitation practiced by the girls. Harkey proceeded to arrest a multitude of couples for violation of the Edmunds Act. Saloon owners soon became frustrated with these actions and began harassing Harkey for his interference in their businesses. It was a slight conflict of interest for Harkey, who owned a saloon himself, but he was nonetheless relentless in his duties.

Phenix officially lasted only a little over three years (although some swear its houses saw action into the 1930s), but in its heyday, it raised enough havoc for three towns.

Sadie Orchard:
Lady with a Heart of Gold

S adie was quite a lady." This statement was repeated many times when residents of Kingston and Hillsboro, New Mexico, were asked to describe Sadie Orchard. This was quite an accomplishment on Sadie's part, especially since she was a celebrated madam in both towns.

Sadie Jane Creech, along with several ladies of the evening with colorful names like Tugboat Annie, Big Sal and Missouri Lil, came to New Mexico Territory in 1886, when Kingston had a population of five thousand. She claimed to be from the Limehouse District of England and even had a Cockney accent. In fact, it was not until the 1940 U.S. Census that Sadie claimed Iowa as her rightful birthplace.

Sadie was the fifth child in an ever-growing family, gaining three more siblings after the Civil War. Born to Bennett Creech and Nancy Davis, Sadie was a farmer's daughter from Lyons, Iowa. It is thought that the young girl's fascination with England came from her many visits with her Iowa neighbors, with whom she would spend many hours listening about the country and its dialect and learning how to ride on horseback.

Life after the War Between the States was difficult for the entire country, and it was compounded for the Creech family when Nancy Creech died when Sadie was only fourteen years old. This event must have had a huge impact on the young girl's life.

When Sadie was seventeen, her grandfather William Creech was tragically killed by a neighbor, devastating her further. It is not known exactly how Sadie got into the prostitution profession, but is certain that it brought her

Sarah Jane Creech, who was born in Iowa but claimed she was from England, created a separate persona—Cockney accent and all. *Courtesy of Larnie Higgins.*

the two things she desired most: respectability and money. In those days, madams were as revered as the sheriff or banker.

Any questions regarding Sadie's past were forgotten in New Mexico.

Kingston boasted that its twenty-two saloons offered over eighty varieties of whiskey available for the throngs of Irishmen, Scotsmen and Englishmen who found their way to the mountain community dubbed the "Gem of the Black Range." It was stated to be the only place in the country where a man could sit down to breakfast a pauper and have dinner a millionaire.

A lady of small stature, weighing in at less than one hundred pounds, Sadie, with her red hair and blues eyes, was a striking figure. And while she

might not have been a great beauty (local newspapers described her as a "fair but frail woman" and "not particularly good looking" after her death), it was her electric personality that drew people to her.

Sadie always dressed to impress, as she desperately tried to live up to her English lady persona. Fine silk dresses and diamond jewelry served as her normal evening attire. Once quoted as saying, "I'd not be caught dead in men's attire," Sadie always rode sidesaddle but was very capable of riding astride—some said better than any man in her hire.

You could always see Sadie riding her high-stepper in a tailored riding habit, which usually included a starched white shirtwaist, an ascot and a pair of imported kid gauntlets. Her tiny feet were adorned by a pair of handmade riding boots hidden by her long skirt. A beautiful silk hat bedecked with plumes rested on her head, accentuating her dark curls. The lady was known for her gold-coin and diamond necklaces, which she wore constantly.

One writer, E.E. Simmons, noted that Sadie "resembled a lady of the manor at an English breakfast hunt, but when she opened her mouth, the resemblance to a gentlewoman ceased. Her obscenities were accented with a wicked chuckle." Sadie was also known to enjoy a drink or two, sometimes enjoying a tipsy ride with the aid of her footman, Boots. Known to have one

Saddles thought to have been used by Sadie Orchard now hang in the Black Range Museum. *Author's collection.*

of the best wine cellars in the region, Sadie also made her own beer and was a bootlegger during Prohibition.

For the most part, Sadie was thought of as the "perfect lady," so no one remembers exactly when or why she became involved in brothels. Ironically enough, her Kingston establishment was located on Virtue Avenue. One can imagine that when she heard of the amount of silver being taken from the hills surrounding Kingston and Hillsborough (as it was spelled during her time), she simply seized an opportunity, just like so many others who flocked to the mineral-rich mountains. (Sadie also provided grubstakes for many of the prospectors, adding to her already established wealth.)

While in Kingston, Sadie realized that the town did not have a church, and she worked to right this omission. The madam passed the hat to all the miners and gamblers who frequented her house, even adding a diamond lavaliere to sweeten the pot. Her girls followed suit, adding diamond rings, while miners added gold nuggets and the gamblers donated stickpins. When all was tallied, they had raised a total of $1,500 for the new building. In later years, when the church was dismantled, Kingston residents obtained stones from the structure to keep in their homes. Materials from Sadie's bawdy houses, hotel and store ended up as foundations for resort homes.

After the Panic of 1893, Sadie moved her operation eight miles to Hillsboro, where the economy was more stable. In his book *Hillsboro: A Story*, author F. Stanley wrote that the town was one of the most "devilish, hair-raising, gun-toting wild spots on the map." Later that year, the area was hit with a smallpox epidemic. The deaths of the children hit Sadie the hardest. She would take care of them and their families both physically and financially, and after their eventual deaths, the silk from her dresses would line the coffins of the young victims. The doctor in the area became overwhelmed and was losing many patients, so Sadie and three of her girls took over. They proudly stated that no one died while in their care.

Other stories recount Sadie's wild side, such as the time she reportedly set the score straight when a gentleman caller stood her up for a date. Leaving all the fineries of the English lady persona behind, Sadie marched up to the gentleman's door, pulled up her fine silk skirt and urinated on the stoop, sashaying away with a small victory.

It was about this time that Sadie met Jack W. Orchard, who, for some unknown reason, was also called Henry. In all accounts, Jack was described as a lackluster fellow who knew a good thing when he saw it and promptly latched on to Sadie's apron strings. The couple was married on July 17, 1893, in Hillsboro. Together, they opened the Mountain Pride Stagecoach

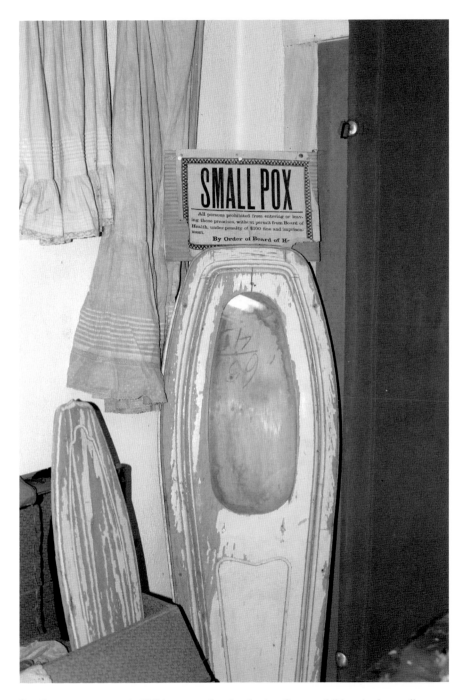

Smallpox ran rampant in Hillsboro, causing the deaths of many children in the small community. Sadie Orchard and her girls would traditionally line the small coffins with silk from their many gowns. *Author's collection.*

One of the rare female stagecoach drivers in the West, Sadie bragged about never having been held up. The Mountain Pride stagecoach used by Sadie is housed in the Lincoln County Courthouse in Lincoln, New Mexico. *Author's collection.*

Line and traveled the torturously steep mountain passages between Lake Valley, Kingston and Hillsboro, with passengers paying two dollars a ride. Sadie was also known to break the horses necessary to run the line.

The *Santa Fe New Mexican* wrote that the Orchards' stage line, which ran for fourteen years, had "the best vehicles, best horses and the best-looking driver in the southwest." "I would drive four to six horses every day from Kingston to Lake Valley and sometimes as far as Nutt Station," Sadie remarked in an interview with Clay Vaden. "Many times I had for passengers very famous people. Lillian Russell, stage star, as far as I know was never in Kingston, but members of her troupe were, and I had an occasion to meet the actress. She was a guest on a ranch west of Hillsboro...the Horseshoe Ranch, I believe."

The old-timers remarked that Sadie, who always carried with her a six-foot bullwhip, would often brag about never having been held up. On one occasion, Sadie was stopped by a small band of Indians, who no doubt saw this petite woman as an easy target. But they were quick to learn that dynamite comes in small packages. Once Sadie had finished lashing the group with her whip, said to be twenty-five feet of plaited leather, she proceeded to give them a tongue lashing that would make an army veteran blush. Needless to say, they gladly left the crazy white lady alone.

One of the Orchards' drivers, Bill Holt, once thwarted a robbery by anticipating an ambush. He stopped the stage and took out the hay from the horse collar and replaced it with the money. The stage was indeed robbed, and when asked where the money was, Holt explained it had been sent ahead. After a search of the coach by the outlaws, Holt was allowed to continue on. For this show of ingenuity, the Orchards awarded Holt a $100 reward.

Old-timers tell of the Orchards having a volatile relationship—especially when they drank together—that ultimately led to a divorce in 1901. James was known to have an eye for the "wild women" and drank more than his fair share of "forty-rod" whiskey. This was a whiskey said to be so strong it could kill from that distance. The recipe included ingredients such as grain alcohol, red chiles, water from the Pecos River, a rattlesnake head and, of all things, a bar of soap. After the concoction was mixed together, a horseshoe was dropped in the mix. If the shoe fell to the bottom of the barrel, more alcohol was added until it rose to the top.

The final straw came when Sadie found out that James had hidden a bottle of the Taos lightning in her favorite grandfather's antique clock, ruining the timing mechanism. He was asked to leave by means of a shotgun pointed at his head. James lost the mail contract on the stage line and eventually sold it to Fred Mister. The Orchards filed for divorce shortly after this transaction. The messy divorce is one of only a few instances in which Sadie had trouble with the law. She was charged and fined for taking a "pot-shot" at her husband with a revolver, stealing his buggy and shooting a deadly weapon. James Orchard would later drop the charges. Although she would keep the Orchard name the rest of her life, Sadie referred to herself as a widow.

Sadie was not one to back down from anything, including dares or wagers. Legend has it that she won $100 after accepting a miner's dare to ride the full length of Hillsboro's main avenue "Lady Godiva style"—covered only by her long dark hair—which caused quite a sensation with the townsfolk.

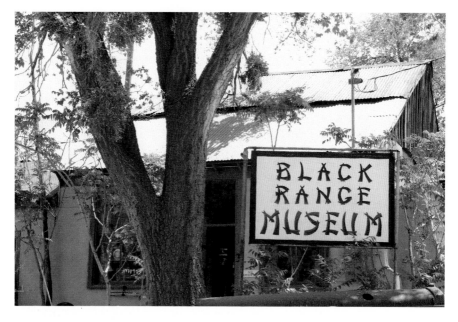

The Black Range Museum is located in Sadie Orchard's old hotel/brothel. If only these adobe walls could talk. *Author's collection.*

Not one to rest on her laurels, in 1896, Sadie built and opened a hotel and pleasure house called the Ocean Grove. The establishment featured one of the finest restaurants in the area, thanks to her Chinese cook, Tom Ying of San Francisco. She also opened the Orchard Hotel and stables. The small adobe hotel would become a hub of business activity over the years and would accommodate guests from all walks of life, including Jesse James, the Dalton brothers and Butch Cassidy. Sadie would keep track of her guests' preferences, social status and how much they spent while in her company. This ledger would prove to be beneficial as a gentle persuader should a politician or other official deny her a project.

Tom Ying would become a trusted friend and confidant of Sadie, and their friendship would last many years. However, the two would eventually sever ties, with Tom leaving Sadie's restaurant and opening his own establishment, the Chinaman's Place, down the street. The large cast-iron oven on which most of his meals were prepared is still a focal point of the Black Range Museum, housed in the remains of the hotel.

It is reported that Tom Ying had a huge distrust for barbers and would only let Sadie cut his hair. He was also the proud owner of the biggest refrigerator in the county by 1930. The Black Range Museum is in

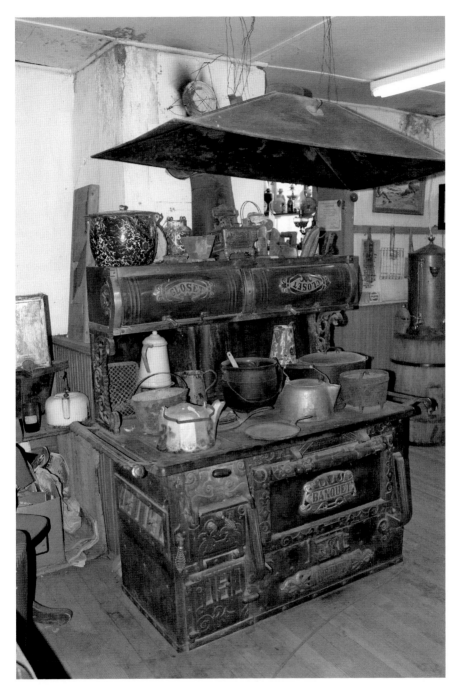

The ornate cast-iron cookstove used by Tom Ying was the focal point of Sadie's restaurant. Ying would later use the stove in his own restaurant. *Author's collection.*

possession of this unit, as well as the many Chinese newspapers Ying had mailed to him in Hillsboro.

In 1899, Hillsboro played host to what many New Mexicans considered the trial of the century after Judge Albert Fountain and his young son disappeared on their way back from Las Cruces. The key players and jury members in the case stayed at Sadie's hotels and were made privy to her opinions of a third conspiracy on the case. When the defendants were acquitted, Sadie threw a celebratory "English garden party" complete with engraved invitations in their honor at the Ocean Grove since she was convinced of their innocence. The case remains one of New Mexico's biggest unsolved mysteries.

Although at times her reputation was less than stellar, Sadie was revered by many. E.E. Simmons wrote, "Despite her morals and her operation of the house on the hill, Sadie was an unusually interesting person with a big heart." This fact was proven time and time again over the years, including during the 1918 influenza epidemic, when Sadie and her girls once again took over the care of many of the afflicted and were successful in saving many lives. The philanthropic madam was known to be extremely generous to her community, earning the envied moniker of "Angel of Mercy."

But Sadie was not without her enemies. The November 22, 1922 edition of the *Albuquerque Citizen* reported that Sadie and three friends, including Mrs. H. Kubale, were sharing a beer when a noise outside distracted Sadie, who went out to investigate. When she returned, she drank a "slight amount" of the beer but threw the major portion away because it was too bitter. She later reported that she became violently ill, and the doctor determined that the illness was most likely due to morphine that had been added to her beer. Mrs. Kubale was arrested but later released due to insufficient evidence. Residents suspected Mr. Kubale may have been one of Sadie's clients.

During the years after her divorce, Sadie become great friends with "Cowboy Chronicler" Eugene Manlove Rhodes, a writer who would add some of Sadie's colorful stories into his tales. Rhodes wrote, "Sadie is getting older, but she is still a bighearted, resourceful woman of frontier times who saw her job, tackled it heroically, and did it manfully with a twinkle in her eye."

In her later years, Sadie's fortune began to dwindle, and she reconnected with Tom Ying. Ying was still the owner and operator of the Chinaman's Place, and the two remained friends until Sadie's death in 1943.

Although it is said that Sadie amassed great fortunes in all her endeavors, she was near penniless when she passed away at age eighty-four. The funeral and burial in Hot Springs (now Truth or Consequences) was attended only by

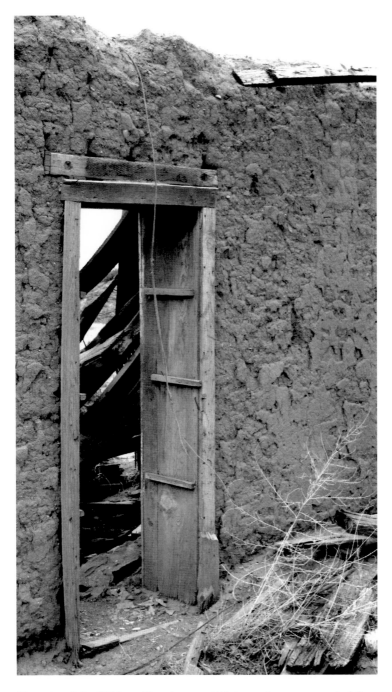

The ruins of the Hillsboro Courthouse, which bore witness to several of the subjects in this book. *Author's collection.*

one sister and one brother. (Sadie was not buried in her beloved Hillsboro because the soil was too rocky to accommodate a grave.) Her lonely grave, the headstone of which was provided by staff members of the Geronimo Springs Museum, regularly receives gifts of flowers from unknown sources.

After her death, Sadie's estate was sold off, and the beautiful furniture that adorned possibly the busiest brothel in the area was said to have been "prized by residents who would have never spoken to Sadie on the street." Once the bills were paid on the estate, there was only forty-five dollars left.

Sadie was a multifaceted woman who lived a full and productive life. Was she truly wicked? At times, yes—but she also played a good part in the lives of many people. New Mexico writer Erna Ferguson wrote of Sadie, "For a bad woman, Sadie was one of the best." But I believe Sadie summed up her life best when she said, "I'm a product of the Old West, and you know, in those days, we didn't have much chance to practice the niceties of high society."

Loma Parda Denizens:
Military Disrupters

Today, the winds of history whisper among the rocky ruins of Loma Parda, a once-vibrant town located about seven miles southwest of Fort Union, New Mexico. As the high desert breezes dance around relics of the past, the stone skeletons of the remaining buildings allude to the violence and debauchery that occurred during the town's existence.

Situated on the Mora River, the quiet farming community of approximately five hundred residents became a hot spot for cowboys, con artists, soldiers and, of course, prostitutes. The shady ladies, some having moved from Santa Fe after seeing the potential for great profit, began to populate the village, which was used as a supply depot for the fort and a stop along the Santa Fe Trail.

The citizens endured many extremes over the years, including drastic weather changes, attacks from native tribes, floods and droughts. Today, according to historian Marc Simmons, Loma Parda "is listed as one of New Mexico's most historic ghost towns."

The majority of Loma Parda's mostly Hispanic population was hardworking and law abiding—people simply trying to scrape by in an unforgiving environment. But as history will attest, these men and women will not be remembered as being decent. The words of author Thomas P. Lowry will determine the town's legacy:

> *A considerable prostitution operation was located not in the village itself, but in caves near the fort where, as early as 1852, street prostitutes from Santa Fe traded sex for goods stolen from the fort's warehouses. In a six-month*

period, the army lost 9,379 pounds of bacon, 5,254 pounds of clear sugar, 4,303 pounds of coffee, and similar quantities of soap, candles and dried peaches. Prominent in these cave-centered transgressions were Maria Alvina Chaireses (AKA "Black Sus") and Maria Dolores Trujigue y Rivale. The post physician had noted sixty cases of venereal disease associated with these female troglodytes and their sisters in sin.

The first of the three Fort Unions was founded in 1851 and housed over 1,300 men who were there mainly to protect the many travelers on the Santa Fe Trail. The fort served as a post to watch over the Hispanic and native populations, as well as provide service as a supply depot

The jail at Fort Union also housed the laundry facilities. Soldiers from the fort and prostitutes of Loma Parda would be incarcerated here. *Library of Congress.*

for the federal presence in the form of the U.S. Army. With the high rate of disease contracted by the soldiers, it was a good thing that Fort Union sported the region's best hospital, which consisted of six wards with thirty-six beds. Care in this hospital was available for a daily charge of fifty cents.

Proprietor Julian Baca ran a casino and cantina in Loma Parda, and this establishment soon became one of the region's most popular gathering places for both derelicts and soldiers. In fact, many of the soldiers went AWOL so often that their commanding officers took notice and tried to restrict them from leaving the fort. Fort Union was the reason Loma Parda existed, but much to the horror if its respectable citizens, the town was eventually burdened with the moniker "Sodom on the Mora," due to its proximity to the Mora River. Loma Lightning was the most popular brand of whiskey offered at the twenty-four-hour dance hall.

Many of Loma Parda's soiled doves used the disguise of laundresses to be given access to the fort. Once there, the women would lure the soldiers back to town or to the surrounding caves in which they had set up shop. Before long, there were more soldiers in Loma Parda than in Fort Union. The problem became so great that an order posted in the fort read, "No enlisted man stationed at Fort Union is permitted to step foot in Loma Parda under any pretext whatsoever!" Any soldier found ignoring the order was severely chastised.

One official, Captain Sykes, became so enraged by the brassiness of the women who disobeyed his orders that he took two of them into captivity and had their heads shaved in public to bring shame upon them and make them less attractive to the men of the fort. The women were then sent back to their pitiful shacks in the caves behind Loma Parda, and from then on, the caves were known as the Bald Woman Caves. Despite the humiliation of the ordeal, the women were not deterred.

One popular story best illustrates the total lack of order in the small village. One night in 1888, James Lafer, a cowboy straight off the range, went on a drunken rampage through the town's streets. During his adventure, he kidnapped one of the ladies of the evening, laid her across his saddle and rode headlong into a Loma Parda saloon. The shocked saloon patrons witnessed a drunken Lafer offer a drink of whiskey to his horse, which was cruelly and unceremoniously shot in the head for its refusal. Happy with his work, Lafer scooped up his captive and left his horse dead in the middle of the saloon floor. Nothing was written regarding how many men it took to remove the poor animal.

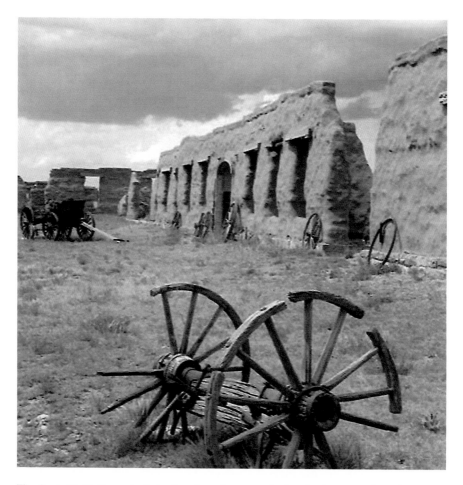

The Santa Fe Trail was the hub of trade and communication for the outreaches of the country. Deep ruts from the many wagons can still be seen. *Library of Congress.*

After Fort Union went out of commission in 1891, the wild women of Loma Parda moved on as well. Interestingly enough, one of the five dance halls was converted into a church. Today, bits and pieces of the once-vibrant pit of debauchery can still be seen—and if those walls could talk, they would make even the most vulgar cowboy blush.

Bibliography

BOOKS

Alexander, Bob. *Dangerous Dan Tucker: New Mexico's Deadly Lawman*. Silver City, NM: High-Lonesome Books, 2001.

———. *Desert Desperadoes: The Banditti of Southwestern New Mexico*. Silver City, NM: High-Lonesome Books, 2006.

———. *Sheriff Harvey Whitehill: Silver City Stalwart*. Silver City, NM: High-Lonesome Books, 2005.

Balcomb, Kenneth C. *A Boy's Albuquerque, 1898–1912*. Albuquerque: University of New Mexico Press, 1980.

Ball, Larry D. *Desert Lawmen: The High Sheriffs of New Mexico and Arizona, 1846–1912*. Albuquerque: University of New Mexico Press, 1992.

Bryan, Howard. *Albuquerque Remembered*. Albuquerque: University of New Mexico Press, 2006.

———. *Wildest of the Wild West: True Tales of a Frontier Town on the Santa Fe Trail*. Santa Fe, NM: Clear Light Publishers, 1988.

Chávez, Thomas E. *New Mexico Past and Future*. Albuquerque: University of New Mexico Press, 2006.

Cook, Mary J. Straw. *Doña Tules: Santa Fe's Courtesan and Gambler*. Albuquerque: University of New Mexico Press, 2007.

Davis, Carolyn O'Bagy, and Terrence M. Humble. *Silver City (Images of America)*. Charleston, SC: Arcadia Publishing, 2013.

Deveraux, Jan. *Pistols, Petticoats & Poker: The Real Lottie Deno*. Silver City, NM: High Lonesome Books, 2009.

Enss, Chris. *The Lady Was a Gambler: True Stories of Notorious Women of the Old West*. Gilford, CT: TwoDot, 2007.

Evans, Max. *Madam Millie: Bordellos from Silver City to Ketchikan*. Albuquerque: University of New Mexico Press, 2002.

Eversole, Linda J. *Stella: Unrepentant Madam*. Victoria, BC: TouchWood Editions, 2005.

Federal Writers' Project. *New Mexico: A Guide to the Colorful State*. New York: Hastings House, 1962.

Florin, Lambert. *Ghost Towns of the Southwest*. New York: Promontory Press, 1971.

Gilbreath, West. *The Story of Legal Hangings in New Mexico, 1847–1923*. Silver City, NM: High-Lonesome Books, 2002.

Haldane, Roberta Key. *Gold-Mining Boomtown: People of White Oaks, Lincoln County, New Mexico Territory*. Norman, OK: Arthur H. Clark Company, 2012.

Hillsboro Historical Society. *Around Hillsboro*. Charleston, SC: Arcadia Publishing, 2011.

Hunter, J. Marvin. *The Story of Lottie Deno: Her Life and Times*. Whitefish, MT: Kessinger Publishing LLC, 2007.

James, Henry. *Madam Varnish and the Golden Era*. Pompano Beach: Exposition Press of Florida, 1979.

Johnson, Byron, and Sharon Peregrine Johnson. *Gilded Palaces of Shame: Albuquerque's Red-Light Districts, 1880–1914*. Albuquerque, NM: Gilded Age Press, 1983.

Keleher, William A. *The Fabulous Frontier: Twelve New Mexico Items*. Albuquerque: University of New Mexico Press, 1962.

King, Patsy Crow. *Sadie Orchard: The Time of Her Life*. Silver City, NM: PDX Printing, 2008.

Krol, Laura V. *Deming (Images of America)*. Charleston, SC: Arcadia Publishing, 2012.

L'Algoe, Bob. *Frontier Gambling: The Games, the Gamblers & the Great Gambling Halls of the Old West*. Kerrville, TX: CreateSpace Independent Publishing, 2011.

———. *Knights of the Sixgun: A Diary of Gunfighters, Outlaws and Villains of New Mexico*. Las Cruces, NM: Yucca Tree Press, 1991.

L'Algoe, Bob, and Virginia Nelson-L'Algoe. *Pistol and Petticoats: 13 Female Trailblazers of the Old West*. Los Lunas, NM: Flying Eagle-Thunderhawk Enterprises, 2005.

Looney, Ralph. *Haunted Highways: The Ghost Towns of New Mexico*. New York: Hastings House Publishers, 1968.

Lowe, Sam. *New Mexico Curiosities: Quirky Characters, Roadside Oddities & Other Offbeat Stuff.* Guilford, CT: Globe Pequot Press, 2009.

———. *Speaking Ill of the Dead: Jerks in New Mexico History.* Guilford, CT: Globe Pequot Press, 2012.

MacKell, Jan. *Red Light Women of the Rocky Mountains.* Albuquerque: University of New Mexico Press, 2009.

Marohn, Richard C. *The Last Gunfighter: John Wesley Hardin.* College Station, TX: Creative Publishing Company, 1995.

Marriott, Barbara. *Outlaw Tales of New Mexico: True Stories of the Land of Enchantment's Most Infamous Crooks, Culprits and Cutthroats.* Gilford, CT: Globe Pequot Press, 2012.

Melzer, Richard. *Buried Treasure: Famous and Unusual Gravesites in New Mexico History.* Santa Fe, NM: Sunstone Press, 2007.

Metz, Leon. *John Wesley Hardin: Dark Angel of Texas.* Norman: University of Oklahoma Press, 1998.

Monahan, Sherry. *Wicked West: Boozers, Cruisers, Gamblers & More.* Tucson, AZ: Rio Nuevo, 2005.

Mucho, Jill. *Murder and Justice in Frontier New Mexico, 1821–1846.* Albuquerque: University of New Mexico Press, 1997.

O'Neal, Bill. *Encyclopedia of Western Gunfighters.* Norman: University of Oklahoma Press, 1979.

Pacheco, Ana. *Legendary Locals of Santa Fe.* Charleston, SC: Arcadia Publishing, 2013.

Parker, Morris B. *Morris B. Parker's White Oaks: Life in a New Mexico Gold Camp, 1880–1900.* Tucson: University of Arizona Press, 1971.

Rakocy, Bill. *Ghosts of Kingston, Hillsboro, New Mexico: A Pictorial Documentary of the Great Black Range Country, ca. 1880s.* El Paso, TX: Bravo Press, 1983.

———. *Ghost Town of White Oaks.* El Paso, TX: Bravo Press, 1998.

Rakocy, Bill, and Rosamond Shannon Jones Rakocy. *Mogollon Diary, 1877–1977: A Ghost Town History.* El Paso, TX: Bravo Press, 1977.

Ray, Grace Ernestine. *Wily Women of the West.* San Antonio, TX: Naylor Company, 1972.

Reynolds, Joyce, ed. *SWNM History: A Collection of Old West Stories, 1300–2000 (Featuring Deming, New Mexico USA & Highlights of Neighboring Towns.* Deming, NM: JReynolds Photo & Camera Works, 2012.

Rose, Cynthia. *Lottie Deno: Gambling Queen of Hearts.* Santa Fe, NM: Clearlight, 1994.

Seagraves, Anne. *Soiled Doves: Prostitution in the Early West.* Hayden, ID: Wesanne Publications, 1994.

Sherman, James E., and Barbara H. Sherman. *Ghost Towns and Mining Camps of New Mexico*. Norman: University of Oklahoma Press, 1975.

Sonnichsen, C.L. *Tularosa: Last of the Frontier West*. New York: Devin-Adair Company, 1961.

Stanley, F. *The Carlsbad Story*. Nazareth, TX: self-published, 1963.

———. *The Loma Parda New Mexico Story*. Nazareth, TX: self-published, 1969.

Tanner, Karen Holliday. *Doc Holliday: A Family Portrait*. Norman: University of Oklahoma Press, 1998.

Tanner, Karen Holliday, and John D. Tanner. *The Bronco Bill Gang*. Norman: University of Oklahoma Press, 2011.

Torrez, Robert J. *Myth of the Hanging Tree: Stories of Crime and Punishment in Territorial New Mexico*. Albuquerque: University of New Mexico Press. 2008.

Turzillo, Jane Ann. *Wicked Women of Northeast Ohio*. Charleston, SC: The History Press, 2011.

Varney, Philip. *New Mexico's Best Ghost Towns*. Albuquerque: University of New Mexico Press, 1981.

Winter, Jonah. *Wild Women of the Wild West*. New York: Holiday House, 2011.

PERIODICALS

Auer, Louise. "Deadwood's Gambling Lady." *Real West* (October 1972): 48–52.

Kildare, Maurice. "The Hanging of Paula Angel." *Real West* (September 1967): 14–15, 54–56.

Liggett, Byron. "Lottie Deno: Queen of Frontier Gamblers." *Poker Player Magazine* (June 2006).

Tanner, Karen Holliday, and John D. Tanner. "Susie Raper: Female Buccaneer of the Sagebrush." *Wild West* (August 2011): 50–55.

About the Author

D onna Birchell, author of three books on local New Mexico history (*Carlsbad and Carlsbad Caverns, Eddy County* and *New Mexico Wine: An Enchanting History*), developed a passion for history through the inspiration of her history buff parents, William and Dorothy Blake. While doing research for her other books, the native New Mexican discovered a lack of written history regarding the slightly tarnished and definitely wicked ladies of New Mexico and thought it was high time that oversight was corrected.

Visit us at
www.historypress.net

· ·

This title is also available as an e-book